METRO DET

FOOTBALL RIVALRIES

Every late summer and early fall, boys sweat, toil, and crash into each other on dusty fields. Girls jump, hurdle, and scream to earn a spot on a cheer team. Hundreds of kids march precise steps to brass and percussion harmonies. Mom and Dad transport kids to the epicenter of it all, the local high schools, in between countless loads of football laundry. It is what is done in metro Detroit, just like the rest of America. Entire communities get involved in high school football. Crowds come out in droves. Schools show colors and students decorate cars. Ultimately, everyone moves on to bigger and better things. Today's participants will graduate from college, go to work, marry, and start families. And the cycle plays itself out over again for a new generation. (TheWriteReferee/Robin Buckson.)

On the Front Cover: Please see page 78. (John Herrington collection.)

On the Back Cover: Please see page 42. (Fordson High School Library archive.)

Cover Background: The 1960 seniors from Royal Oak Kimball are seen here. Down 21-7 to top-ranked Ferndale and All-State quarterback Mike Brown, Kimball rallied for a 33-21 win. Coach Prentice "Pin" Ryan said of the win, "That was my most memorable win—beating Ferndale really put us on the map." Ryan went 48-16-5 as Kimball's first head coach from 1957 to 1964. The loss knocked Ferndale from 1960's final Top 10. Kimball also stunned the heavily-favored Bathers of Mount Clemens in 1960 by a 25-6 count. (The Daily Tribune.)

METRO DETROIT'S HIGH SCHOOL FOOTBALL RIVALRIES

T. C. Cameron

ARCADIA PUBLISHING

Copyright © 2008 by T. C. Cameron
ISBN 978-0-7385-6168-4

Published by Arcadia Publishing
Charleston SC, Chicago IL, Portsmouth NH, San Francisco CA

Printed in the United States of America

Library of Congress Catalog Card Number: 2008925862

For all general information contact Arcadia Publishing at:
Telephone 843-853-2070
Fax 843-853-0044
E-mail sales@arcadiapublishing.com
For customer service and orders:
Toll-Free 1-888-313-2665

Visit us on the Internet at www.arcadiapublishing.com

CONTENTS

Acknowledgments		6
Introduction		7
1.	The Catholic League and the Public School League	9
2.	Wayne County	21
3.	The Dearborn Dynamic	33
4.	Oakland County	47
5.	Gone But Not Forgotten	61
6.	Farmington Hills Harrison	75
7.	Macomb County	87
8.	Playoffs, Championships, and All-Star Games	97
9.	The Great Coaches	107
10.	We've Got Spirit	117

ACKNOWLEDGMENTS

The author extends his sincere thanks and acknowledgment to the following individuals and organizations for the assistance in making this book possible.

Thanks to Jeff Ruetsche and John Pearson at Arcadia Publishing, for giving me 18,000 more words than any other editor or publisher gave me.

Thanks to the many high schools profiled in word, picture, or both, whose athletic directors, coaches, librarians, assistants, and archivists made yearbooks, collections, and information available to the author.

Thanks to John Johnson, communications director for the Michigan High School Athletic Association (MHSAA). Your encouragement and advice proved prophetic.

The author would like to thank the many individuals who make high school football special in so many ways, starting with the many student-athletes and participants. Players, marching bands, pep bands, cheerleaders, dance teams, and student cheering sections. This is never possible without you and you are the blood, sweat, and guts of Friday night's lights.

To the photographers and writers who cover the high school sports with the same energy and devotion that any worthy journalist gives to a worthy story or event they cover. These professionals represent the *Oakland Press* in Pontiac, the *Daily Tribune* in Royal Oak, and the *Observer and Eccentric* in both Birmingham and Livonia. More than ever, our metropolitan community needs local writers and photographers working at local papers. These publications make our cities, neighborhoods, villages, and townships viable communities and places worthy of rooting our families in.

Thanks to Tim Busch of TBSportPix.com, the premier for-hire sports photographer in metro Detroit.

Finally, I thank my family for the support, time, and well, mostly the time, to complete this project. When I was not refereeing, or working a referee's event, or blogging about refereeing, or writing for refereeing publications, I was writing this book.

INTRODUCTION

My earliest recollections of high school football are those of my Dad, Joseph P. Carey, the referee for the Saginaw-Arthur Hill game annually played on Thanksgiving Day. I often went with him as a kid and got into the games for carrying his football shoes. They were played back then only at Alumni Field, Saginaw High's home field. I worked at WCEN in Mount Pleasant, my first radio job, before moving on to WKNX-Radio in 1953. WKNX decided to broadcast the Saginaw-Arthur Hill contest in 1954 and I did the play-by-play. The following year was the final Thanksgiving Day game and I did the play-by-play from Arthur Hills's stadium.

A fellow named Len Colby, working at WKZO in Kalamazoo, was the inspiration for my doing a scoreboard show. When I got to WJR in June of 1956, I thought WJR was perfect for the scoreboard show since it were heard across a much larger area than WKZO. I was a bit presumptuous in calling my show "The Michigan High School Football Scoreboard," but it was the only such show that covered as much area. I convinced sports director Bob Reynolds to ask programming to allow it. They said yes; it did not cost anything and gave WJR extra programming. I was a staff announcer until 1965 but it was the toe in the door of sports for me at WJR. I followed the football show with a basketball scoreboard a year later that ran on Tuesday and Friday winter nights after the midnight news.

I gave the Detroit scores first, we would break for commercial and I would give the suburban scores next. I usually started the suburban scores with Royal Oak for two reasons. My wife and I lived in Royal Oak in a two-bedroom apartment on Crooks Road directly across from Royal Oak Kimball High for 17 years, from 1964 to 1981. Kimball had very good success yet I never saw a football game there because I always worked Fridays and Saturdays. I knew Prentice "Pin" Ryan and Herb Deromedi when they coached Kimball. Royal Oak Dondero was in the Border Cities League with Wyandotte, Monroe, Dearborn Fordson, Grosse Pointe South—one of the toughest leagues in the state—and then Dondero would end the season with Kimball.

In 1973, I joined Ernie Harwell on Detroit Tiger baseball. It was daunting on the Friday nights I had to dash from Tiger Stadium to the WJR studios in the Fisher Building after a game. Every season there would be a couple of nights I would plow through the wrap-up of the Tiger game, race down the outside ramps to the parking lot on Michigan Avenue, and speed up the Lodge Freeway. A few games ran so long we preempted the news and sports blocks on WJR, but I would still do a scoreboard show—even at 12:45! Most Friday nights I did Sports Wrap at 11:15 p.m. and that made it quite difficult to collect scores for the scoreboard. In 1956, my sources were the *Associated Press* (AP), *United Press International* (UPI), and *International News Service* (INS) wire services to get Detroit-area scores. I also worked with *Detroit Times* sports editor Eddie Hayes, who gave his approval for me to get scores either from George Maskin or Morrie Moorawnick, later the super statistics man for the Detroit Pistons and Red Wings. The *Times* folded and I made a deal with *Free Press* sports editor Lyall Smith. Maskin and Moorawnick

moved over to the *Free Press* and Moorawmick continued to feed me scores after 11:30 p.m. I owe a lot to Maskin, Hal Schram, Mick McCabe, and all the guys who worked those Friday nights.

Getting results and making sense of them could be difficult, but because I grew up in Michigan, I knew how to pronounce city names, where they were located, and how important their game was. I would make up a blank page on Thursdays, using the schedules from the *Free Press* and *Detroit News* and fill in scores via the phone on Fridays. There were some regular contributors calling in scores but often I did not have time to answer calls while preparing a 15-minute sports show to go on at 11:15 p.m.

There was a mystique about the scoreboard show and yes, I mean "mystique" in talking about the media today. When I was a kid and many years after that, I could listen to radio and draw a picture in my mind as to what was happening. Television deprived us of that in giving us all the pictures and answers. I was very fortunate to get into radio when it still had some mystique. The only source for scores was the AP or UPI, so people had to either listen to me or wait to buy a paper the next day. Today there is no need for the show I did—go to the internet and get the scores minutes after the game is completed. Back then coaches would stop me to tell me they would listen to check on scores of future opponents or to find out how their coaching friends made out and often it was in a social gathering, listening to the show I broadcast.

Some of the men I dealt with were Bill McCartney (Dearborn Divine Child High School—Colorado University), Lloyd Carr (Westland John Glenn High School—University of Michigan), and regulars included George Sahadi (Harper Woods Bishop Gallagher–Harper Woods Notre Dame), Don Lessner (Riverview High School), Paul Smarks (athletic director of Warren Schools and founder of the Michigan High School Coaches Association), John Dean (now closed Detroit Northern), and I would get a call every Friday night from Msgr. Stanley E. Milewski, who was athletic director at Orchard Lake St. Mary's.

For two years, I anointed the Thom McAn Player of the Year. I would pick the player, make arrangements to get his football shoe gilded—a heck of a trophy—and make a presentation at halftime of a basketball game. The first one was a player from Detroit, a lineman who would later become a starting center and captain at the University of Michigan. The second year was Gary Danielson, who played at Dearborn Divine Child and later for the Purdue Boilermakers and Detroit Lions.

I was on the AP ratings panel for about 10 years and on the all-state panel for over 15 years, responsible for Detroit and Wayne County. To this day, I still collect the *AP*, *Detroit Free Press*, and the *Detroit News* all-state football teams every year from Florida and make a composite just for my own sake. In all the years I did the football and basketball scoreboard shows, the only time I was paid was 1961, when the Pistons sponsored the basketball show and I got $15 per broadcast. I could have cared less—the Michigan High School Scoreboard Show is one of my fondest memories of my days in radio, including Detroit Tiger baseball, because I know high school football means so much to the people of metro Detroit.

—Paul Carey

1

THE CATHOLIC LEAGUE AND THE PUBLIC SCHOOL LEAGUE

Perhaps some day they will return to their former companionship, a past that most in metro Detroit would call the golden age of high school football. They are the Catholic High School League (known simply as the Catholic League) and the Detroit Public School League (PSL). Yes, there was a day the two leagues were practically intertwined at the hip. Their respective league champions battled at Tiger Stadium in the season's last game—the Goodfellows Game. The winner was often crowned as state champion by the media.

Early parochial school perennials were St. Ambrose, Notre Dame, Catholic Central, and St. James. The PSL, or the former Metropolitan League, was represented by Pershing, Denby, and Cooley or University of Detroit High. Then University of Detroit became University of Detroit (U-D) Jesuit and rejoined the CHSL and Martin Luther King opened, quickly becoming a PSL power. Birmingham Brother Rice opened in 1962. The PSL and CHSL champions stopped playing one another when the Goodfellows Game ended in 1967. The high school playoffs came to fruition in 1975. The city championship was for the PSL, and the Prep Bowl winners came from the CHSL. Their lineage became two leagues housed in the same city.

Today the two leagues play one another in nonleague, crossover games. Their relationship of one to the other will never pass. They still use the same officials, and it is not uncommon for a crew working a PSL game at 4:00 p.m. on a Friday to become a CHSL crew at a 7:30 p.m. While the Catholic League has long been a title contender and ultimately, a state champion many times over, King High School's 2007 championship, the first ever for a PSL school, was long overdue and earned the city a share of respect it long craved and sorely needed.

Today's Catholic League and PSL might look like polar opposites when compared to the days they were identical twins. They are really just two brothers that grew older but never grew apart when it came down to heart and soul.

Detroit Pershing coach Michael Haddad, right, instructs one of his young charges in a 1962 game versus Detroit Cass Technical High. Pershing won 28-12. Haddad was the only coach in the Detroit PSL of Syrian decent and hailed from a miner's town in Pennsylvania. Pershing graduate Orlin Jones said of Haddad, "He was something else—a tough sonofabitch—but a hell of a good man, too." (Orlin Jones collection.)

Coach - Haddad Sept. - 1962

John Matsock 1st Doughboy - To Play In A Rose Bowl Game Michigan State vs UCLA - 1954

1950 Pershing vs Miller at Mack Park - Night Game Returned Opening Kick-Off 95 Yards For his First of 3 Touchdowns

Mich.-State Football Baseball Basketball

David Gibson Half-Back

Pershing Doughboys' John Matsock (left) and David Gibson formed the blue and gold's one-two punch in 1949. Gibson was a versatile halfback who carried the ball effectively and blocked with punishing precision. Matsock, gifted with speed and agility, played tailback and returned kicks and went on to play three sports at Michigan State University, including starring for the Spartans in the 1954 Rose Bowl, a 28-20 Spartan win over UCLA. (Ronald Thorne/Orlin Jones collection.)

TOP ROW: LtoR: Emil Dalak, Asst. Coach, Emerson Hockenhull, Alexander Wright, Charles Shonta, Willia
 Kutchen, Joe Groppuso, Rupert Mynatt, Emerson White, Albert Day, Edward Benford, Ray Geisler,
 Richard Garcia, Martin Thomas, Carl Phillips, Lewis Robinson, Marvin Geisler, Donald Vaughn,
 Mike Haddad, Head Coach.
MIDDLE ROW: Tommy Green, Asst. Coach, Harold Lautenback, Kenneth Baldwin, Eugene Cecchini, George
 Genyk, Robert Fontanesi, Lyle Hildebrand, John Soave, Jim Ninowski, Richard Frankensteen,
 James Smela, Chester Michalski, Herman Headen, Loren C. Bow, Principal
BOTTOM ROW: Ronald Fontanesi, Mgr. Gerald James, Benton Finney, Donald Moery, William Schade, Kenneth
 Bates, Gerald Smith, Allen Hendrick, Robert Prouty, Larry Askew Mgr.

After the 1953 Doughboys finished off Detroit Catholic League champion Our Lady of Lourdes 21-7 in the Goodfellows Game, the *Detroit Times* made Pershing a unanimous choice for the season's No. 1 team, earning Pershing a mythical state title. There was nothing mythical about the straightforward, smash-mouth Doughboys, who outscored their opposition 303-55. (Orlin Jones collection.)

The 1956 Doughboys went 6-0-1. Their only blemish a 14-14 tie with rival Detroit Denby High. More important than their record was their harmony; black and white seated next to one another and no dissenters refusing to look forward. "We were respectful of one another back then. It didn't matter if you were black or white; if you could play, you played, but no matter what, we were all Doughboys. It was that simple," said Pershing graduate Bill Hardy, who later played at the University of Michigan. (Orlin Jones collection.)

METRO DETROIT'S HIGH SCHOOL FOOTBALL RIVALRIES 11

Ivy Loftin was named one of Northwestern's best from 1940 to 1950 by coach Sam Bishop. A guard on the Colt team of 1948, Loftin poses before the Metropolitan League title game at the now demolished University of Detroit stadium. Loftin landed a coaching job at Royal Oak High under coach Jim Manilla in 1953. When Royal Oak High split into Kimball and Dondero High, Manilla assumed the district's athletic director's job and Loftin became Dondero's leader for 27 seasons. (Ivy Loftin collection.)

Playing in front of a capacity crowd at the University of Detroit, Mackenzie's Stags ran past Pershing High in the 1944 Metropolitan League title game. Mackenzie High was a perennial contender for many years in the public school's league championships until closing in 2006. Also closing in 2006 was Redford High. The Huskies of Redford and Mackenzie had a long rivalry that passed on unceremoniously when both schools were shuttered. (Orlin Jones collection.)

THE CATHOLIC LEAGUE AND THE PUBLIC SCHOOL LEAGUE

In 1944, Detroit Northwestern's football practices took place in front of newly built buildings surrounded by dusty, overused fields. This is a practice for the Colts of Detroit's Northwestern High, and in the background of this picture is the Lee Plaza building. Another Detroit edifice, the Olympia Stadium, sat just blocks from this intersection at Grand River Avenue and McGraw Street. (Ivy Loftin collection.)

Coaches in the 1950s and 1960s suited up for practice, just as players, in jerseys and pants, evidenced by the Pershing coaching staff to the right for the 1955 team picture. Maybe that pushed the Doughboys to an undefeated seven-game run to the Metropolitan East title. The blue and gold won the city title over Detroit's Western 14-7 and topped Redford St. Mary's 13-7 in the Goodfellows Game at Briggs Stadium. Pershing outscored opponents 222-33 in 1955. (Orlin Jones collection.)

Doughboys Break The Denby Jinx

SE Game To Decide Title

by Gurney Beach

Pershing's great backfield consisting of Kenny Baldwin, Harold Lautenbach, John Soave, and Jim Ninowski combined their talents to smother Denby 30-13 Friday, October 23, at U of D Stadium.

The game started in typical Denby-Pershing fashion, with the ball being exchanged back and forth until late in the first quarter.

Harold Lautenbach and John Soave sparked a drive that was to begin the worst defeat in Denby's history and Pershing's greatest victory. Fleet-footed Lautenbach ran the ends for five and ten yards, and Soave hit the center for sizable gains until the ball was on Denby's ten yard line. The two pony backs had Denby's defence going in circles as Lautenbach started another run and bulldozed his way into the end zone for a touchdown. Jim Smela missed the extra point. The score stood Pershing 6, Denby 0.

In the second quarter Soave ran straight up the center for a 55 yard gain.

Grid Squad Batters Eskies with Soave, Lautenback, Ninowski

The Doughboys moved another step toward the East Side Championship by battering Northern 38-13 Friday, October 9, at Jayne Field.

The Doughboys took the opening kickoff and marched 60 yards down the field with Harold Lautenback going the final 4 yards.

John Soave was the star of the game with two touchdowns. One of them came on a three-yard plunge through the center of the Eskies' line, and the other on a 38-yard sprint with an intercepted pass.

The Doughboys were led by the brilliant ball handling of Jim Ninowski who threw two touchdown passes, one for 23 yards, and one for 37, to his team mate Eugene Cecchini.

Ken Baldwin smashed over from the one-yard line to score after Soave returned a kickoff for 75 yards.

Coach Haddad uncovered a good prospect in Donald Morey for quarterback next year.

Top Picture: Halfback Hal Lautenbach grabs pass out of air, and is tackled five

Denby's spell of victories over Pershing died in 1953 when Pershing escaped the Tars' clutches with a 30-13 win, as reported by the *Pershing Chronicle*, the school's student newspaper. Along with Denby and the now closed Miller and Mackenzie, Pershing was among the schools to beat in the 1950s. From 1953 to 1956, Pershing had an astounding 35-2-1 and for the decade of the 1950s, the Doughboys went 47-15-2. (Orlin Jones collection.)

```
1964 Football Pershing High School       COACH - HADDAD
       Win 5 - Lose 1 - Tie 1
Pershing   6    Roseville    0
   "       7    Cass         6
   "       6    Northern     0
   "       0    Mumford      0
   "      19    Eastern      0
   "       7    Central     21
   "       7    Denby        6
```

Notice the truly diverse team intermingled within the ranks of Pershing personnel by 1964, and the winning tradition continued for coach Mike Haddad. Of note is the victory over the Roseville Wildcats, as the Detroit public schools began playing outside their stable of city proper counterparts. Of their seven games in 1964, three schools have closed or been renamed. Roseville added Brablec High in 1967 as a city rival and then consolidated in 1998, Northern's Eskimos folded in 2006. Eastern High School burned to the ground in the late 1960s. (Orlin Jones collection.)

Perhaps no school in metro Detroit enjoyed a more dominating run in prep football's golden age than Detroit Denby. From 1950 to 1969, the Tars went 129-22-5, a streak that included five undefeated campaigns and 11 seasons of just one loss. After beating Cooley's Cardinals for the city title, Denby escaped the Shamrocks by a 21-18 count in the 1960 Goodfellows Game (program seen here). The AP rewarded Denby with a season-ending statewide rank of No. 3. (CHSL archive.)

Catholic League powerhouse Orchard Lake St. Mary's (OLSM) long enjoyed a spirited game with another Oakland County private powerhouse, Detroit Country Day. In 1988, Country Day gave OLSM their toughest game of the year until the Prep Bowl in the last week of the season. Here an Eaglet back breaks away as veteran official Dick Lisbeth sees the play in OLSM's 14-7 win. Lisbeth, a member of the Catholic High School League hall of fame, is remembered for a long stint of officiating in the Mid-American Conference. (Observer and Eccentric.)

METRO DETROIT'S HIGH SCHOOL FOOTBALL RIVALRIES

Emotion, elation, and unbridled joy befit Detroit Catholic Central's Pete Elezovic (44) and Leo Kowalyk (87) after this game's final play, the winning field goal lifting the Shamrocks past archrival Birmingham Brother Rice in the Boys' Bowl of 1995 at Pontiac's Wisner Stadium. Perhaps no game in metro Detroit over the past 50 years has captured more of a rivalry's essence than the Rice-CC game. (Observer and Eccentric/John Stormzand.)

The big boys of the Catholic League take center stage in this file photograph of Brother Rice and Catholic Central from Pontiac's Wisner Stadium around 1994. The two rivals have met 45 times since Brother Rice opened in 1962; Catholic Central holds a slim 23-22 advantage with the 1968 battle ending in a 0-0 tie. Since 1975, the two rivals have combined for 28 Michigan High School Athletic Association (MHSAA) semifinals, 22 championship games, and 15 state titles. Rice has won six trophies; Catholic Central has captured nine. (Observer and Eccentric.)

Immovable object meets unstoppable force—and object wins—as this Catholic Central defender crushes his rival counterpart from Brother Rice. The two schools are mirror images of each other in the prep football scene in metro Detroit. Since 1950, Rice's overall record is 355-110-4 while Catholic Central touts a 406-147-5 mark. (Observer and Eccentric/John Stormzand.)

Even the slightest gap might equal glory when Catholic Central and Rice meet. Here the Shamrocks burst for a touchdown in 1992's 14-7 win over Rice at a sold-out Winser Stadium. In 1992, Catholic Central went undefeated in 13 contests in marching to the Class AA MHSAA championship. The Shamrocks beat playoff foes Troy 9-6, Utica Eisenhower 17-14, and Saginaw Arthur Hill in the title tilt 21-20, proving narrow margins of victory a forte in 1992. (Observer and Eccentric.)

Shamrock Jeff Messano is downed by Rice's Jerry Rioux in Catholic Central's 14-9 win in 1987's MHSAA Class A semifinal. Rare is a pair of wins over a rival twice in a season, but Catholic Central was victor and victim of that trick in 1987. On September 18, Catholic Central dropped a 7-2 setback at Ann Arbor Pioneer but escaped Brother Rice in both the regular season (October 9) and in the MHSAA semifinals (November 20). Pioneer completed the same trick Catholic Central exacted on Rice when the Pioneers doubled up the Shamrocks in the Silverdome, winning the title game, 3-0. (Observer and Eccentric.)

The "Brad Cochran Rule," designed to penalize transfers for athletic reasons, was put in place by the MHSAA after Cochran bolted Royal Oak Dondero High after his junior season in 1979 and played at Brother Rice in 1980. With Cochran (shown above), Rice won the 1980 Class A championship. Cochran went to the University of Michigan and later the Oakland Raiders. He tried to mend fences at Dondero by donating used Michigan weight room equipment after his playing career ended but Dondero refused; the equipment went to Dondero's rival, Royal Oak Kimball, where Cochran's brother Brett played. (Daily Tribune.)

The Catholic League has never shied from playing the better public schools, as Catholic Central's David Owens finds Ann Arbor Pioneer's Dan Kanda at Pioneer's Hollway Field. In 1974, Catholic Central and other metro parochials started playing public schools. From 1975 to 2000, the Shamrocks played either Pioneer High, Ypsilanti's Braves, or both save for four seasons. Playing schools with big enrollments helped the Shamrocks earn 11 MHSAA semifinals, nine finals, and six titles in the same 25-year span. Pioneer earned MHSAA championships in 1984 and 1987. (Observer and Eccentric/Steve Jagdfeld.)

Madison Heights Bishop Foley faces fellow Catholic League rival Harper Woods Bishop Gallagher at Foley in a 1992 Mud Bowl. Gallagher closed in 2001 and reopened as Harper Woods Trinity, a collaborative of three schools that included St. Florian in Hamtramck, Detroit's East Catholic High School, and Bishop Gallagher. Foley opened in 1966 and has remained a Catholic League stronghold since. Foley's biggest rival is neighboring Royal Oak Shrine, a longtime staple of the Catholic League. (Daily Tribune/Craig Gaffield.)

Royal Oak Shrine was bolstered in the mid-to-late 1970s by Royal Oak native John Wangler, who led the Shrine Knights before accepting a scholarship from coach Bo Schembechler at the University of Michigan. Wangler, overcoming a knee injury, became a hero of Michigan's 1980 Big Ten championship and 1981 Rose Bowl 23-6 victory over the University of Washington. (Oakland Press/Tim Thompson.)

2

WAYNE COUNTY

Perhaps the state's most powerful league never to win a state title did so in 2007 when Detroit Martin Luther King captured Michigan's Division II championship. Before King's decisive 47-21 victory over the Midland Chemics at Detroit's Ford Field, Wayne County's biggest league, the Detroit Public School League (PSL), suffered from a stigma of being good enough to compete but not to be champions.

Nothing is further from the truth. Wayne County, or the PSL for that matter, is not defined by how many trophies fill glass cases. If one mentions the Detroit's Pershing Doughboys, Westland's John Glenn Rockets must also be mentioned. If one brings up Detroit Denby, Dearborn Fordson must also be included. There is a civil war fought in Grosse Pointe between North and South High School every year. Allen Park High School on a Friday night is pure Jaguar passion. From schools representing Livonia to the magnificent rivalries between the "fearsome foursome" in Dearborn and the great rivalry between Riverview Gabriel Richard and Allen Park Cabrini, there is a story to be told in Wayne County.

In the post–World War II days, the PSL was better known as the Metropolitan League. In those days the strongest teams were Hamtramck, Pershing, and Detroit Denby. The first high school game between Denby and Pershing was played in 1931, and the two continue to be rivals today. Hamtramck competes today in the Metro Conference and another Metropolitan League school, University of Detroit High School, became University of Detroit (U-D) Jesuit and rejoined the Catholic High School League (CHSL) in 1958.

Rivalries have remained in Detroit between Renaissance's Phoenix and Cass Tech's Technicians, Pershing's Doughboys and Osborn's Knights, and finally Denby's Tars and King's Crusaders. Two schools closed in 2006, Redford's Huskies and Mackenzie Stags, were longtime rivals in the PSL.

Wayne County's best have earned scholarships and all-league and all-state honors. In the Great Lakes footprint and beyond, Wayne is well represented on collegiate rosters at all levels across the nation.

Today Wayne County is like any other suburban conference, as a select number of schools play on synthetic, recyclable fields with new lights, bleachers, press boxes, and scoreboards. With King putting the 2007 state championship trophy in its case, the MHSAA's football championship truly comes through Detroit and Wayne County.

John Glenn quarterback lets it loose as Harrison defensive lineman Joe Hannawa bears down in the 1988 game. The Rockets played Harrison 12 times from 1970 to 2001, winning five and dropping seven, and several Western Lakes Athletic Association championships were decided in the John Glenn-Harrison game. The rivalry ceased when Harrison left the Western Lakes to join the Oakland Activities Association in 2002. (Observer and Eccentric/Randy Borst.)

Two schools who have worn the University of Michigan's winged helmet, at different intervals, with pride are Dearborn Fordson and Wayne Memorial, shown here in this October 11, 1991, game won by Fordson, 14-6. Wayne Memorial holds an obscure but special footnote in high school sports because of their nickname, the Zebras. The school picked that name because of their student body population of black and white students (Observer and Eccentric/Art Emanuele.)

Westland John Glenn's Dale Yanick celebrates teammate Brian Satterlee's tackle for loss, one of few plays to celebrate in a 45-7 loss to Farmington Hills Harrison. Glenn would post an 8-1 record and play two playoff games in 1988 while Harrison went 13-0 en route to the Western Lakes league title and the Class B MHSAA championship. (Observer and Eccentric/Randy Borst.)

Rolling to the right, Livonia Franklin's quarterback throws for a score in the Patriots' 15-14 win over city rival Livonia Stevenson in the 1995 game. Livonia Franklin won the MHSAA's first Class A football championship in 1975, when the Patriots defeated Traverse City High 21-7. It would be 30 years before Franklin returned to the playoffs in 2005. (Observer and Eccentric/Steve Jagdfeld.)

Franklin's Kyle Percini ran over, around, and through Farmington Hills Harrison in this 31-0 thrashing of the Hawks in 1992. Franklin's biggest games of the year are generally earmarked for city rivals Livonia Stevenson and Livonia Churchill. Given Harrison's outstanding record and consistency in winning high school football games, any victory over Harrison is a season highlight. (Observer and Eccentric/Art Emanuele.)

The lights burn bright for Livonia Stevenson as a Spartan tailback scores a touchdown around 1990. Opened in 1966, Stevenson has posted winning records in 31 of its 42 seasons. Nothing topped 2007, when the Spartans posted a 13-1 record, defeating traditional rivals Franklin and Churchill and winning the Western Lakes' Lakes Division. Stevenson won four-straight games before bowing to Macomb Dakota in the championship game at Ford Field. (Observer and Eccentric.)

John Glenn stretches for and gets a first down in this 1991 game with the Raiders of North Farmington High. The Western Lakes is known as a tough, hard-nosed football conference, which proved truthful on this day as the Raiders edged John Glenn 21-20. North Farmington ended 1991 with a 6-3 mark and received a surprise playoff game, won by the Ypsilanti Braves 14-7. John Glenn finished 7-2 but did not qualify for the tournament. (Observer and Eccentric/Lee A. Ekstrom.)

After advancing to the MHSAA playoffs, Glenn tries to advance the football across the goal line versus perennial power Detroit Catholic Central in a November 11, 1988, playoff game. Catholic Central earned a gritty 21-6 decision over Glenn and became runner-up for the MHSAA championship. Glenn is one of a handful of schools in the Detroit metro area to have fielded many great teams without winning a championship. (Observer and Eccentric/Steve Fecht.)

The Wayne Memorial Zebras break up a John Glenn pass in front of a packed house in their annual Western Lakes conference game played November 1, 1993. In 1993, John Glenn earned glory and heartbreak when the John Glenn Rockets advanced to the MHSAA championship game, only to lose to Dearborn Fordson 12-7. Glenn defeated the Zebras on this night, 42-22. (Observer and Eccentric/Art Emanuele.)

Kyle Percini prepares to hit the hole in the Livonia Franklin Patriots' annual rivalry game with Livonia Stevenson in 1992. That season, Franklin defeated their rivals from Livonia Stevenson and Churchill and won a stunning 31-0 victory over previously undefeated Farmington Hills Harrison. In the 2007 campaign, all three Livonia schools earned a tournament invitation. Franklin advanced to the MHSAA semifinal before losing to Stevenson. (Observer and Eccentric.)

Westland John Glenn star Bryan Besco celebrates his team's only score in a 10-7 loss to the Warriors of Walled Lake Western High on October 23, 1992. This photograph gives strong insight into the game responsibilities of high school football officials, especially to sell the big call when it is needed most. Glenn was undefeated before dropping this game; Western went to the MHSAA championship game before dropping a 21-18 decision to Muskegon Reeths-Puffer at the Pontiac Silverdome. (Observer and Eccentric/Dan Dean.)

The raw emotion, hope, and spirit of high school football in metro Detroit is captured to perfection as the sideline for Livonia Churchill awaits the outcome of the play in their 10-6 triumph over city rival Livonia Franklin in 1985. A successful football campaign can embolden the entire student body with confidence, while a poor football team can depress a school year before it even starts. (Observer and Eccentric/Dan Dean.)

METRO DETROIT'S HIGH SCHOOL FOOTBALL RIVALRIES 27

Steve Tracy misses this potential touchdown pass and a chance at glory in Livonia Churchill's tilt at Livonia Stevenson. However, it is the participation, effort, and enthusiasm that matters most in high school football. Unlike professional or big-time collegiate football, fans do not boo players, and peer pressure is about each player doing their very best no matter what the scoreboard reads at the end of the night. (Observer and Eccentric/Art Emanuele.)

Wayne County's North versus South civil war, takes place in Grosse Pointe every year. The 1996 game, shown above, was played in a blizzard at Grosse Pointe South's iconic campus. Here the Blue Devils are driving North's Norsemen to the goal line in the second quarter of a 38-28 victory by North. Longtime South coach Mike McLeod, who led the Blue Devils in this game, sadly passed during the 2006 season before South's game with Romeo. His memory is revered by many South faithful. (J. Richard Dunlap.)

Grosse Pointe South stretches to block a field goal attempt by village rival Grosse Pointe North in the 2002 game, a 15-13 South win. South was better known as Grosse Pointe High until 1968 when rival North opened. The Pointers had strong rivalries with fellow Border Cities League (BCL) members Monroe High, Dearborn Fordson, Highland Park's Polar Bears, and the Acorns of Royal Oak High, who later became the Oaks of Royal Oak Dondero High. Detroit Tiger broadcaster Paul Carey said of the BCL, "Hands down, one of the toughest leagues in the state." (J. Richard Dunlap)

Grosse Pointe's tony shops and tree-lined streets belie the gritty resolve of Grosse Pointe North, one of the most successful high school football programs in Michigan since the school opened in 1968. This photograph shows North, in their all-gold uniform, in 2003's 25-12 win over South. With an overall record of 249-128 and a winning percentage of .660 (through the 2007 season), the Norsemen place 43rd against the 619 schools that offer football in Michigan. (J. Richard Dunlap.)

Plymouth Salem's Ryan Johnson infiltrates John Glenn's defense. Plymouth Salem, nicknamed the Rocks, shares a multiple-acre campus with rivals Plymouth Canton (Chiefs) and Plymouth High (Wildcats). It is a unique situation unlike any other school district in the greater Detroit footprint. The newly built Plymouth High, opened in 2001, adds a dimension to the two-school rivalry that has been described as terse yet spirited. (Observer and Eccentric/Art Emanuele.)

Spartan spirit surely soared after this Livonia Stevenson touchdown was scored by the Stevenson signal caller. Veteran referee Fred Castelvetere watches from his post, 12–14 yards behind the original line of scrimmage. As many metro Detroit schools replace grass fields with recyclable, synthetic surfaces, the grass-stained and mud-soaked uniforms are disappearing. (Observer and Eccentric.)

Livonia Stevenson tailback Lance McKenzie breaks into the clear versus Livonia Churchill. Despite some spotty success from all three Livonia high schools in the 1980s and 1990s, attendance for rivalry games remained strong, as shown here, a packed house at Livonia Stevenson High School. When the MHSAA made the tournament open to every school with six wins or more, the reality of achieving a playoff berth bolstered attendance, because a pair of losses no longer dimmed a season's success. (Observer and Eccentric/Art Emanuele.)

Wayne thunders upfield with the kickoff in their 1991 game with the Tractors of Dearborn Fordson. Unlike the massive stadiums of Ohio, Texas, and Florida, many metro Detroit high schools are nestled within neighborhoods, and those homes provide the backdrop to some of the best rivalry games in the area. This shot shows the Fordson field during better days. Fordson's gridiron often resembled a mud pit for most of the season until 2007, when the Tractors installed a state-of-the-art field made of synthetic grass woven into a bed of recycled tire bits. (Observer and Eccentric/Art Emanuele.)

3

THE DEARBORN DYNAMIC

Nothing represents Detroit metro's unique, socioeconomic diversity better than Dearborn. Unlike any other suburb or pocket within the Detroit-area footprint, Dearborn's high schools march to a different beat. The established from the city's oldest neighborhoods represent the Dearborn High's Pioneers. The city's differing ethnic backgrounds assemble at Dearborn's Edsel Ford High. The privileged attend the Catholic League's Divine Child High. And then there is Dearborn Fordson, a school as unique onto itself as any to be found nationwide.

High school football has always mattered most in Dearborn, where rivalries reach mythical proportion. Since 1928, when automobile magnate Henry Ford financed the great majority of a $2 million gothic masterpiece, the Forson Tractors became a red-letter game to all opponents they faced. Then Fordson had an exclusively European-white enrollment. They were good, won league titles, and quickly built a legion of loyal-hearted fans. Hamtramck, Grosse Pointe High, Royal Oak's Acorns, and Monroe's Trojans all marked the Tractors. Edsel Ford opened—another rivalry born. Fordson's enrollment today is nearly all Arab American and Muslim, and the football success remains.

Prep football always has room for a story like Dearborn, where schools feud and games are long remembered, their stories retold as if they are part of the family fabric. It makes for compelling copy for newspapers. It is talked up at diners, coney islands, and the water coolers of Ford Motor Company.

Divine Child has long been a Catholic League powerhouse, fielding multiple title-contending teams and some years, that was not enough to carry the title of city champion. Dearborn High's love-to-hate relationship with Fordson results in the game being scrubbed for years at a time, while Dearborn's rivalry with Edsel Ford has always been spirited. Edsel Ford's Thunderbirds never pass on a chance to play their neighbors. In 2006, Fordson alum and head coach Jeff Stergalas left Fordson to be an assistant coach at Dearborn, stoking an already-searing fire.

In so many ways, Dearborn is bedrock suburban Detroit. A unique culture and passion, evolved in a city better known for its exclusion of diversity 50 years ago, is now one of the metro area's melting pots and a destination for fiercely contested high school football.

WELCOME MUSKEGON

Dedication Game

Muskegon vs. Fordson

FORDSON, MICHIGAN
NOVEMBER 17, 1928

OFFICIAL PROGRAM

The program from the stadium dedication tells a story of the past without having to open the front page. The dedication game, played with visiting Muskegon High School from the west side of the state, was played on November 17, 1928. Today that date would be the weekend of the MHSAA's semifinal of the football tournament. The other is the location, listed as Fordson, Michigan. During the mid-to-late 1920s, the township of Fordson debated joining the city of Detroit or city of Dearborn. The voters picked Dearborn and the high school was named Fordson to honor the former township name. (Fordson High School archive.)

Head coach Robert LaPointe of Dearborn Divine Child is presented with the MHSAA championship trophy after the Falcons defeated Saginaw MacArthur High School 20-3 in 1975. The Falcons got past traditional rival Royal Oak Shrine 41-6 and escaped Birmingham Brother Rice 7-0 in the Knights of Columbus Prep Bowl. In 1975–1976, the state playoff consisted of the top four teams in each class playing a two-weekend tournament. (Lil' Café, Dearborn.)

The 1963 Dearborn Edsel Ford Thunderbirds earned a record of 4-4 and the title of snake bitten along the way. While Edsel had little trouble with now-closed Taylor Center (27-7), Allen Park (19-0), Ypsilanti (20-0), and rival Dearborn (20-0), the 'Birds dropped three games by a touchdown or less. The Railsplitters of Lincoln Park also got past Edsel 20-7, who competed in the now-defunct Huron-Rouge League. (Lil' Café, Dearborn.)

METRO DETROIT'S HIGH SCHOOL FOOTBALL RIVALRIES 35

The Pioneers of Dearborn High School pose for the 1964 team photograph behind the school building they still occupy. The Pioneers earned a 4-2-2 mark in 1964, victorious over Southgate's Sabers (closed in 1982), Wayne Memorial's Zebras, Melvindale's Cardinals, and Ypsilanti's Braves (since renamed the Phoenix). Dearborn dropped a pair to both Lincoln Park and rival Edsel Ford. One tie was a 6-6 hand shaker with Livonia Bentley, which closed in 1985; the other a scoreless deadlock with hated Dearborn Fordson. (Lil' Café, Dearborn.)

Dearborn Divine Child celebrates its Knights of Columbus Prep Bowl win at Eastern Michigan University's Rynearson Stadium in Ypsilanti on November 7, 1975. The win clinched the Catholic League's Double-A title, and the news kept improving for the Falcons, who were invited to the inaugural field of the first ever high school title tournament two days later. After defeating Sturgis and Saginaw MacArthur on consecutive weekends, the Falcons were Class B champions. (Lil' Café, Dearborn.)

Here is the junior varsity football team, around the early 1930s, from Dearborn Fordson High School. Notice the tower to the right of the smoke stack in the middle background. Fordson opened its school in 1928, thanks in large part to financing from Ford Motor Company and Henry Ford, and played in a state-of-the-art stadium on the school's campus until 1957 when the facility was condemned. (Fordson High School archive.)

Running back Robert Millington earned all-state honors for leading his Dearborn High School Pioneers to an undefeated campaign in 1950. The Pioneers, after a season-opening scoreless tie with Jackson High, rattled off eight straight wins, including a 13-12 margin over Birmingham High (now Seaholm) and a 45-13 thrashing of the Dearborn Lowrey Polar Bears (closed in 1969). For good measure, the Pioneers topped Fordson 14-0 and outscored their opponents 177-31. (Lil' Café, Dearborn.)

METRO DETROIT'S HIGH SCHOOL FOOTBALL RIVALRIES

Edsel Ford, with the ball, attempts a trap to the left side of the line in a game played in the 1964 at Edsel Ford. The Thunderbirds went undefeated with a 7-0-1 mark; their only blemish a 7-7 tie in the season's final game with Allen Park. Edsel Ford defeated traditional rivals Fordson 21-6 and, as shown in this picture, a 27-0 triumph over Dearborn High. (Lil' Café, Dearborn.)

The defense of Birmingham Brother Rice finds its way to the Divine Child ball carrier while avoiding the game's umpire—much to his relief—during Divine Child's 7-0 win in the Catholic League's Knights of Columbus 1975 Prep Bowl. This game was played at Eastern Michigan University's Rynearson Stadium. Today the Catholic League plays its championship games in Detroit's Ford Field, home of the Detroit Lions and Super Bowl XL. (Lil' Café, Dearborn.)

The orange and black of the Dearborn High Pioneers run head on into a Thunderbird-sized wreck after an option pitch is finally corralled outside the hash marks in this 1960s game at Dearborn High. Notice the referee, who is not wearing a cap. This was an optional decision in the 1950s and 1960s for game officials. Many of the caricature program covers from that era featured capless referees. (Lil' Café, Dearborn.)

The Edsel Ford Thunderbirds, Dearborn Fordson Tractors, and everyone else in this picture are at a loss for where the ball is during Fordson's gritty 6-0 win over Edsel Ford in 1963. The Thunderbirds went 4-4 that season, while the Tractors compiled a 5-3 campaign in the now-defunct BCL. Fordson's season highlights were this win over Edsel, a 12-7 victory at Grosse Pointe High (now Grosse Pointe South), and a 33-18 triumph over now-closed Royal Oak Dondero. (Lil' Café, Dearborn.)

The Thunderbird quarterback calls out the cadence versus Dearborn Pioneers (in white) on October 26, 1962, a week after dropping a showdown with Lincoln Park for the Huron-Rouge championship. Edsel went 7-1 in 1962, earning a 24-6 win over Farmington High's Falcons, a 7-6 victory over Allen Park, and this 21-7 pasting of rival Dearborn. The Pioneers went 3-4-1 in 1962. (Lil' Café, Dearborn.)

Edsel Ford fakes a counter play versus the Pioneers after handing the ball to their fullback, shown here smashing into the pile in Edsel Ford's 1962 victory over Dearborn. These photographs and others can be found at Dearborn's Lil' Café, a diner on Michigan Avenue in downtown Dearborn. Its banquet room was converted to host the Dearborn High School Hall of Fame. (Lil' Café, Dearborn.)

A play still used by most high school football teams today is seen in this 1962 photograph of Edsel Ford (black) and Dearborn. Notice the Edsel Ford tight end (80) chopping Dearborn's defensive end. The tackle (78) is blocking straight ahead to open the other side of the hole while the guard pulls toward the camera. The quarterback has faked the ball to the fullback (21) and options the ball to the halfback (36). He also could hand the ball to the flanker (22). (Lil' Café, Dearborn.)

The Fordson Tractors, wearing their Michigan-styled winged helmets, and the Hamtramck Cosmos slug it out at Fordson High in 1936. The Fordson-Hamtramck tilt was an early must-see game in metro Detroit. Hamtramck was then a member of the Metropolitan League, which later became the Detroit PSL. This photograph was taken in the Fordson Stadium, a facility that hosted several Catholic League playoff games in addition to Fordson's home schedule until it closed in 1957. (Fordson High School Library archive.)

The Fordson brain trust of 1957 poses for a preseason picture that ran in the September 17, 1957, edition of the *Detroit News* in the paper's prep football preview. This is Fordson head man Mike Megregian and his three captains for 1957. The Tractors went 6-1 in 1957, earning identical 26-0 wins over Grosse Pointe High and Royal Oak Dondero and a 38-0 thrashing of Monroe. Their only blemish was a 27-13 setback at the hands of Edsel Ford. (Fordson High School Library archive.)

While most schools were still trying to teach their players to run between the tackles in the most basic blocking formations, Edsel Ford was offering weight lifting clubs. Here the muscle of the Edsel spirit is shown in the gym, around 1965. Opening in 1955, Edsel Ford High School immediately showed a resolve and spirit most high schools would take years to cultivate. The Thunderbirds played anyone, anywhere, fully prepared to win. Their rivalry with Fordson is one born of mutual respect. (Lil' Café, Dearborn.)

Fordson gridders Ted Yanchula (left) and Ralph Craddock ready themselves for action in this 1958 season picture from the Fordson yearbook, the *Fleur De Lis*. The Tractors had split results in 1958, defeating Edsel Ford and Monroe but dropping games to Royal Oak Dondero and Grosse Pointe High. This photograph is significant because for the first time in 30 years, the Tractors were without their marquee stadium, which was condemned and later demolished after the 1957 season. (Fleur De Lis, 1959.)

Fordson Halfback and team captain Jerry Slavik scores his third touchdown of the game in a Fordson win over Wyandotte that was covered by the *Detroit News*. This picture ran in the paper the day after the game and while the year is unknown, it is believed to be 1958 or 1959. The Tractors played day games without stands after their famous stadium was condemned. (Fordson High School Library archives.)

METRO DETROIT'S HIGH SCHOOL FOOTBALL RIVALRIES

In 1962, the Monroe Trojans came to Fordson and delivered the Tractors a 32-13 setback. Here a pass from Fordson quarterback Phil Laurenty is picked off by a Monroe defensive back as Fordson's Tom Dunn (22) watches in vain. The rivalry Fordson has enjoyed with Monroe is one of the longest-running rivalries of local flavor. The two schools have switched leagues a handful of times and remain steadfast rivals. (Fleur De Lis, 1963.)

Fordson running back Gary Haverty (21) falls across the goal line to score the Tractors' second touchdown of the day in a 20-12 win over rival Edsel Ford at Fordson in 1959. This was the first win of the season for Fordson, which dropped a 25-19 decision to Lincoln Park one week earlier. Fordson earned a 5-3 mark while competing in the BCL, where they remained until 1973 when the BCL folded and they joined the Great Lakes. The Thunderbirds went 5-2-1 in 1959. (Fleur De Lis.)

Year, date, and opponent unknown, the grand scale of Fordson's stadium is nevertheless captured in this picture. The facility featured a tunnel leading players from the school's locker room into the stadium and was the envy of most other schools. The concrete eroded quickly, however, and the stadium's existence lasted 30 short years. In 1957, the facility sat empty after being declared unsafe for use and was pulled to the ground a year later. (Fordson High School archive.)

Although records for most high schools football games go back almost 60 years in metro Detroit, the winner of this game was conspicuously absent from the handwritten note atop this program's cover. Edsel Ford opened in 1955 and Divine Child opened in 1960, so this was, for all purposes, the true city championship in 1948. Dearborn defeated Fordson 12-7. In 2006, longtime Fordson coach Jeff Stergalas left Fordson to become an assistant at Dearborn. The rivalry is as fierce as it was nearly 60 years ago. (Lil' Café, Dearborn.)

METRO DETROIT'S HIGH SCHOOL FOOTBALL RIVALRIES 45

The Hamtramck Cosmos used to play one of the toughest schedules in the state in the 1930s, 1940s, and 1950s when they competed in the old Metropolitan League. In addition to a yearly game with Fordson, as shown in this 1934 contest at the Fordson stadium, the Cosmos battled Detroit public school powerhouses like Pershing, Denby, and Cooley. The year 1950 was the last time the Tractors and Hamtramck locked horns. It is believed the players with the vertical stripes in this picture represent Hamtramck High while the plain shirts are the blue and gold of Fordson. (Fordson High School archive.)

4

OAKLAND COUNTY

Oakland County high schools have been privy to some of the best high school football games in the metro area for the past 50 years. Thanks in no small part to the baby boomers that filled Detroit's bedroom communities like Ferndale, Berkley, Royal Oak, and Hazel Park in the early 1960s, swelling these cities beyond capacity. Little more than 10 years after Royal Oak High School split into Kimball and Dondero, Birmingham became Seaholm and Groves. Southfield added Southfield-Lathrup High School in the early 1970s. Not surprisingly, these schools won for many years, including 27 consecutive seasons without a losing ledger from Royal Oak Kimball from 1957 to 1983. Contests between Hazel Park-Ferndale, Madison-Lamphere, and Kimball-Dondero emerged as marquee games.

Population surged northward into emerging cities like Troy, Rochester, Lake Orion, and Clarkston. Between 1984 and 1999, Troy High School enjoyed a dominating run unlike any public school has enjoyed since. Troy's rivalry with Athens livened, and Rochester Adams became Rochester High's rival. Soon after, population moved west, too. Small communities no more, Novi and Northville produced upsets and wild finishes. Walled Lake's schools split once in 1969 to produce the Central-Western game and again in 2003 with the addition of Walled Lake Northern. South Lyon became a Class A school, making their games with Milford and Lakeland as important as their annual game with Brighton. In the 1980s, the Lake Orion-Clarkston match-up became one to circle in red too.

Finally, Oakland County would not be what it is without Catholic schools, most notably Birmingham Brother Rice and Orchard Lake St. Mary's. Rice's annual war with Detroit Catholic Central is a must-see game for as long as most can remember. Madison Heights Bishop Foley and Royal Oak Shrine have staged some epic games, and many recall Shrine's games with Dearborn Divine Child that requires mention as well. It was not uncommon to watch Kimball-Dondero battle on a Friday night at Kimball in front of 8,000–10,000 fans and see that same amount come out in the same stadium for Shrine's game with either Divine Child or Foley the following night. Finally, St. Mary's game with Detroit Country Day, a well-to-do school nestled within Beverly Hills, was an annual test of wills and a benchmark of success for each school.

Needing a field goal on the game's final play to defeat Bloomfield Hills Lahser on September 5, 1988, Birmingham Seaholm's celebration begins in earnest in the Maples' 23-22 win over the Knights. Seaholm's primary rival of recent years is Birmingham Groves, although the game with Hazel Park High created a buzz when longtime coach Chuck Skinner left Hazel Park and came to Seaholm. (Daily Tribune/Craig Gaffield.)

After dropping a 28-27 decision to Bloomfield Hills Lasher to open 1982, Birmingham Seaholm rattled off eight straight wins, including a 19-7 win (shown above) over rival Birmingham Groves at the Pontiac Silverdome. Many rivalry games in Oakland County made their way from high school campuses to the home of the Detroit Lions in the 1980s. Groves and Seaholm have split eight games in the current decade. (Birmingham Observer and Eccentric.)

Rochester Adams defender Dennis Edwards hauls down his Rochester opponent in the 1988 game between the two suburban rivals. Perhaps the greatest edition of this rivalry was the 1993 game. Adams's Highlanders and Rochester's Falcons, both undefeated, met in the season's finale. Rochester edged Adams 21-14 to earn a playoff berth but dropped a 30-14 decision to Detroit Henry Ford the next week. Adams won a Division I state title in 2003. (Observer and Eccentric/Duane Burleson.)

Brian Carmody watches his Highlander teammates in the 1988 game between Carmody's Adams squad and rival Rochester High. The Falcons defeated Adams 21-12 to complete an undefeated season and clinch the Metro Suburban Athletic Association title. Had Adams won this game, they would have tied Rochester for the league crown. The win clinched a playoff berth for Rochester, but the Falcons were blanked by Utica Eisenhower 6-0 the next week. (Observer and Eccentric/Duane Burleson.)

METRO DETROIT'S HIGH SCHOOL FOOTBALL RIVALRIES

Troy Athens did not evade rival Troy High on this play but the Red Hawks did post a 7-0 win over their highly successful rivals in 1988. From 1984 to 1999, Troy High posted an outstanding overall record of 134-32, including two championship game appearances and the 1994 title. Against Athens the Colts hold a 23-17 advantage, yet Athens has taken six of the last nine meetings. (Observer and Eccentric.)

Troy's Colts ran down 10 consecutive opponents in 1992, including the rival Troy Athens Red Hawks, 27-0 (pictured above), in winning the now-defunct Southeastern Michigan Association title. Troy advanced to two state finals in 15 years (1985, 1994), winning a state title but in this season were nipped in the playoffs by Detroit Catholic Central 9-6. Troy avenged a bitter 1991 loss to Athens, who defeated Troy in the last-ever game at the original Troy High by a 34-20 count. (Daily Tribune/Craig Gaffield.)

Pontiac Central and Catholic Central battle inside Pontiac's Wisner Stadium in the first round of the 1991 MHSAA playoffs. Catholic Central handed the Chiefs of Pontiac Central a 37-15 loss. Pontiac Central is named the Chiefs for the obvious reference to Chief Pontiac, the namesake of Pontiac. The old Pontiac High split into Central and Northern High in 1959, but for almost 50 years, Central still wore their Pontiac High School jersey, a reference to the school's long and proud past. (Observer and Eccentric/Art Emanuele.)

A pair of disappointing seasons for two powerful teams clashed on November 22, 1957, when Ferndale's Eagles traveled up Woodward Avenue to meet Pontiac High in Wisner Stadium. Pontiac High quarterback Bill Davis, with the ball behind a pair of blockers, plows into the end zone in the 26-6 win for the Chiefs. Ferndale ended up 3-5-1 in the Eastern Michigan League while Pontiac was 3-6 in the Saginaw Valley Conference. (Bill Davis collection.)

Waterford Kettering celebrates in 1964 after capturing the Naval Reserve Trophy, awarded to the annual winner of the Waterford Township–Waterford Kettering game. The Captains took a 13-6 decision over the Skippers on this night en route to an 8-1 record and a Tri-County conference championship in 1964. Waterford Township High closed in the spring of 1983, leaving Waterford Mott as Kettering's lone local rival. (Waterford Kettering Kismet, 1965.)

Waterford Mott High opened in 1967 and began a rivalry with Waterford Kettering in 1969. The Corsairs defeated Kettering in 10 consecutive seasons, including the four years collegiate All-American and World Series hero Kirk Gibson played for Kettering. That streak died gloriously for Kettering in 1979, who stormed the field at the Silverdome after defeating Mott 21-18 for the first time in school history. Kettering won 10 of the next 12 meetings. (Waterford Kettering Kismet, 1980.)

Every high school football game begins with the night's first contest, the coin toss. Here Kettering correctly calls heads before coming out on the short end of a hard-fought 13-7 loss to the Milford High Redskins. Milford competed in the Wayne-Oakland conference in 1968 and later changed their nickname to Mavericks. Starting in 1974, Milford's main rival was Milford Lakeland, later identified as White Lake Lakeland. (Waterford Kettering Kismet, 1969.)

Opening their season at their rival, Northville quarterback Eric Lampela pitches to tailback Dennis Singleton in the 1975 Baseline Jug game with neighboring Novi High. The Mustangs posted a 20-6 win in a rivalry that has been punctuated by upsets. Novi, which opened in 1966, added Northville to the annual football schedule in 1971 and will play their arch rival for the 40th time on October 10, 2008. (Northville Palladium, 1976.)

In 1988, Novi entered the Baseline Jug game with an undefeated bandwagon in tow, an 8-0 record, a Kensington Valley Conference crown, and the top ranking in Michigan's biggest football division, Class A. Northville, by contrast, owned an uninspiring 3-5 record. By the end of the night, Northville had their fourth win and the Baseline Jug in hand after upsetting Novi 23-18. Novi recovered and advanced to the Class A championship game, bowing to Traverse City 13-12. (Northville Palladium, 1989.)

With a knee down and a yard short of an upset, Northville's signal caller falls to the turf in Novi's 20-16 win in the annual Baseline Jug game in 1982. The win moved Novi to 7-2; Northville fell to 3-6. In the all-time series of the two neighbors, the Wildcats have scored 23 wins for Novi while the Mustangs have earned 16 wins. The game's trophy was donated by the *Novi News* after the original jug turned up mysteriously missing. (Northville Palladium, 1983.)

Before being crushed into the turf, Northville quarterback Ryan Huzjak pitches out to his tailback in the Baseline Jug game. A Northville upset often capped a less-than-thrilling mustang season. There have been a handful of times the loser of the Baseline Jug game has still managed to make the playoffs, and twice the two teams have faced each other after playing the climatic final game. Northville swept Novi in 2000; Novi broomed the Mustangs in back-to-back games in 2004. (Northville Palladium.)

Clarkston quarterback Dane Fife eludes a Lake Orion defender in the Wolves' 20-0 victory over the Dragons in 1991. The two schools joined the Oakland Activities Association (OAA) in 1994, and did not play from 1957 to 1976, but the rivalry reveals a slim 20-18 edge for Clarkston. In 2006, Lake Orion won the regular season game but lost a playoff game to Clarkston. The Dragons returned the favor in 2007 when they dropped the scheduled game and revenged the Wolves in the playoffs. (Oakland Press/Doug Bauman.)

During a 20-year break in the Clarkston–Lake Orion rivalry, the Dragons found other Oakland County teams to battle with, including this 1972 game with Madison High's Eagles. The Dragons also found a healthy rivalry with the Oxford High Wildcats. In 1979, the team either played or scheduled only one game, a 2-0 forfeit loss to Madison High. (Lake Orion Dragon, 1973.)

Oxford pursues the Dragons in this 1968 game at Lake Orion, won 13-6 by the Dragons. Oxford's Wildcats are currently coached by longtime leader Bud Rowley and compete in the Flint Metro League. Oxford plays schools like the Fenton Tigers, Holly Bronchos, and Flint Kearsley Hornets. Oxford posted 26 consecutive winning seasons through 2007, winning the Class B state title in 1992. (Lake Orion Dragon, 1969.)

Victorious in the school's biggest game of the year since it opened, South Lyon's raucous celebration suits the Lions after defeating Brighton High in 1977, avenging a 52-6 beating the year before. The two schools have played since before World War II. In 2004, the Lions lost a 17-9 decision to Brighton in the regular season but beat the Bulldogs in the first round of the MHSAA playoffs. Brighton swept both a conference and playoff game with the Lions in 2005. (South Lyon Informer, 1978.)

A fumble in any game between rivals Walled Lake Central and Walled Lake Western often provides the edge in achieving victory. Overall the series advantage lies with Western's Warriors by a 24-17 margin. Central High used to be Walled Lake High but was renamed when Western opened in 1969. Western won Class AA titles in 1999 over Utica Eisenhower and 1996 defeating Sterling Heights Stevenson. Western also earned semifinal appearances in 2001 and 1992. (Observer and Eccentric.)

Ferndale clinched the first playoff berth in school history when they defeated Hazel Park 28-9 in the 1987 regular season finale. Ferndale and Hazel Park sit opposite each other to the west and east of Woodward Avenue, between Eight Mile Road and I-696. The two districts share buildings and other district resources. This makes their game unique because most of the players know their opponent very well outside of football. (Hazel Park High School Archive.)

In the fall of 1974, the MHSAA put forth a paper playoff, a test run of a mathematical points-based system to try to start a football tournament. The Vikings, who had posted 23 wins in their last 27 games, went a perfect 9-0 in 1974, including the 25-0 win over Ferndale shown above. This was the last year the state's high schools did not play a football tournament. In 1975, Hazel Park went 5-4, Ferndale 7-2, and Royal Oak Dondero 8-1—none qualified for the playoffs. (Hazel Park High School archive.)

The annual Hazel Park–Ferndale game is usually the most competitive game of the year for these south Oakland County rivals. The series, being played in 1980 above, is extremely close with the Eagles holding a 39-33-6 margin over Hazel Park's Vikings. In games since 1950, the tally reads 29-28 for Ferndale. There is no trophy for the game, although a jug from Hazel Park's rivalry with Berkley sits in the Hazel Park atrium, the awarding of which has long been discontinued. In this contest, the Vikings won a gritty 20-6 decision over their neighbor to the west. (Hazel Park High School archive.)

HAZEL PARK vs. FERNDALE

**HOMECOMING GAME HONORING
COACH GRBA AND DADS OF PLAYERS**

—— Officials ——

John Neville — Charles Leadbetter — Ray Grables

NEXT HOME GAME—GROSSE POINTE—OCT. 27 — 2 p. m.

This is the program for Hazel Park's annual tilt with Ferndale on October 27, 1949, with a military theme to boot. This annual rivalry was usually "Dad's Night" for the school to host the game. This program is also of interest for the listing of the officials working the game on the front of the cover, something never seen in today's game. The next game for Hazel Park was Grosse Pointe High, reminding everyone of an era when schools played based on competitive balance without socioeconomic reasons added to the equation. (Hazel Park High School archive.)

60 OAKLAND COUNTY

5

Gone But Not Forgotten

Some of the classic games that metro Detroiters still regale in story today are no more.

The Metropolitan League championship games (now called the Detroit PSL) played at Wayne State University's Tom Adams Field or the now-demolished University of Detroit Stadium are retold with a nod to the passion and glory they evoked. Many of the biggest playoff games in both the Catholic League and PSL history, including championship games, were played by schools no longer in existence.

Veteran officials who accept games today speak in reverent tones of working a game between the fierce city rivals from Royal Oak Dondero and Royal Oak Kimball at Lewis Cass Field. From the late 1950s to the mid-1980s, the Oak Stump Game in Royal Oak was attended by 8,000–10,000 fans. It was a game that was as thrilling to win as it was devastating to lose.

Harper Woods Bishop Gallagher and Warren De LaSalle played for the Propeller Trophy for many years until Gallagher closed in 2004. It is rumored that longtime Gallagher coach Tom Masserang holds possession of the Propeller trophy today. De LaSalle's Oil Can Game with St. Joseph's ended in 1962 when St. Joe's merged within the De LaSalle student body.

A handful of schools played an annual rivalry game on Thanksgiving Day. After World War II, most high schools slowly discontinued football. That tradition rekindled, in part if not parcel, when the MHSAA began holding its championship games on Thanksgiving weekend in 1975.

Birmingham High School annually played the Acorns of Royal Oak High School for the Little Brown Jug. When Royal Oak High School split into two high schools, Birmingham became Seaholm High School and their biggest rival became Royal Oak Kimball until Birmingham Groves opened. Royal Oak's schools have battled Birmingham's high schools in 146 games.

And perhaps no game is more fondly remembered than the Goodfellows Game at Briggs Stadium, later renamed Tiger Stadium, on Thanksgiving evening. The Goodfellows Game was an annual pairing of the Catholic League and PSL champions in the last week of the season. Another game that is no more is the Soup Kitchen Game, which was played at University of Detroit or Wayne State University.

The last Brown Jug Game between Birmingham's Maples and Royal Oak's Acorns (in dark jerseys) was played after a healthy snowstorm on Thanksgiving Day 1956. Players from both schools reportedly assembled hours before the game to remove the snow from Royal Oak's Cass Field. The stadium was named for former Michigan governor Lewis Cass, who named Royal Oak quite by accident when, in 1819, he proclaimed a large oak tree within the village limits to be a "Royal" oak. The Acorns whitewashed the Maples 19-0 on this Turkey Day. (The Varsity Shop.)

Weather in any Turkey Day game was a factor. Fans came prepared with adult beverages, and exploits in the stands were of legendary lore too. In the 1940 game, Royal Oak's Bobby Martin raced onto the field with a borrowed shoe to kick the winning field goal on the last play of the game. The Acorns won 3-0. Royal Oak's Doc Morrison and Birmingham's Tom "the Bomb" Tracy were recognized as each school's best player when the rivalry ended in 1956, pictured above. (The Varsity Shop.)

The final Brown Jug Game played in 1956, shown above with Birmingham in striped helmets, also brought an end to several other traditions, including alumni dances on the eve of the game for both schools and a march through downtown for the Royal Oak faithful. Many former Royal Oak or Birmingham greats returned to serve their alma maters when the schools split in 1957 into Royal Oak Dondero and Royal Oak Kimball to the south, Birmingham Seaholm and Birmingham Groves in 1960, to the north. Royal Oak held a 24-14 advantage in Brown Jug Games. Seven contests ended in ties. Royal Oak forfeited the 1925 game but their 1935 squad was recognized as state champion. (The Varsity Shop.)

Birmingham head coach Vince Secontine (middle) and assistants pose for this picture around 1955. Rivals to the north and south of each other on Woodward Avenue, Birmingham and Royal Oak played every year from 1913 until 1956, save for 1914 and 1920–1921. The first Thanksgiving Day game of the rivalry was either 1915 or 1916 and in 1924, Eva Moore, advisor to Royal Oak High's *Acorn* newspaper, conceived the idea of the jug as a trophy. Birmingham end John Shepherd painted the jug red, white, and blue. Fifty years after the last Brown Jug Game, Secontine's son, Marc, keeps the game's trophy at the family store, the Varsity Shop in downtown Birmingham. (The Varsity Shop.)

Royal Oak Kimball's Mike Kenealy evades Birmingham Seaholm's Chris McCarus in 1980. Birmingham lost another Royal Oak rival when Royal Oak Kimball was renamed Royal Oak High School to accommodate displaced students of Royal Oak Dondero, who played their final season in 2005. When Kimball opened in 1957, the Knights resolved to beat Birmingham before Dondero became their true rival. Kimball-Seaholm often decided the Southeastern Michigan Association (SMA) championship. Kimball held a 24-20-1 margin in the 45 games the two schools played. (Daily Tribune/Craig Gaffield.)

The Soup Bowl Game was the Catholic League's championship tilt on an annual basis but ceased in 1975 when the league renamed their championship the Knights' of Columbus Prep Bowl. That title remains today for the Catholic League, which hosts their football championship at Detroit's Ford Field, home of the Detroit Lions. This program featured always-tough Grosse Pointe St. Ambrose versus Catholic Central. St. Ambrose, coached by George Perles on this day, defeated the Shamrocks, 37-0. (CHSL archives.)

METRO DETROIT'S HIGH SCHOOL FOOTBALL RIVALRIES 65

This type of caricature art was commonplace on the covers of high school football programs nationwide in the 1950s and 1960s, and this game, simply titled High School Championship Football Game, was actually the Goodfellows Game. Briggs Stadium was later renamed Tiger Stadium in 1961 and hosted the final Goodfellows Game in 1967. The Detroit PSL and Catholic League no longer match their respective champions. Nicknamed the Teutons, Detroit St. Anthony High closed in 1968. (CHSL archive.)

In 1952, Catholic League champion Redford St. Mary's faced University of Detroit High in the Goodfellows Game at Briggs Stadium. Until 1958, University of Detroit High, now known as the University of Detroit-Jesuit, was a member of the West Division of Metropolitan League, which later became the PSL. The St. Mary's Rustics faced a University of Detroit High team that was undefeated and had outscored their public school competition 226-6. St. Mary's delivered a 13-6 upset on this night. The school closed in 1992. (CHSL archive.)

GONE BUT NOT FORGOTTEN

Detroit Pershing is a PSL institution, simply known as the Doughboys, or alternatively, the Soldiers, in metro Detroit circles. Here the blue and gold faced 1953 Catholic League champion River Rouge's Our Lady Of Lourdes, which closed in 1974. Pershing won the game 21-7. Often the Goodfellows Game, last played in 1967, was played after the annual Thanksgiving Day Game at Briggs Stadium played by the Detroit Lions and Green Bay Packers. (CHSL archive.)

Tiger Stadium was once known as Briggs Stadium and was flanked by streets named Cherry and Vernor, not Cochrane and Kaline. The stadium stopped hosting high school games just prior to the NFL Detroit Lions leaving in 1974. Until 1999, the stadium did host the Detroit PSL and Catholic League's championship baseball games, as well as the statewide East-West All-Star prep baseball game. (CHSL archive.)

METRO DETROIT'S HIGH SCHOOL FOOTBALL RIVALRIES 67

Royal Oak Kimball, wearing winged helmets, aggressively blocks Royal Oak Dondero's defenders trying to thwart them in the Oak Stump Game of 1965, won by Kimball, 33-0. The win completed Kimball's first of five undefeated seasons. The two schools combined for 28 league titles, 32 seven-win seasons, and 12 appearances in the Associated Press's season-ending poll from the 1950s until the two schools, described as historic rivals by the *Detroit News*, merged in 2006. (Kimball Lancer, 1966.)

Kimball defensive end Darby Stewart closes in on Dondero quarterback Dave Charleton in the 1966 Oak Stump Game. Undefeated, No. 2 Dondero faced SMA champion Kimball as more than 10,000 fans, including 3,000 who braved the train tracks to the west of Cass Field, watched the game. Dondero scored first, Kimball took a 14-7 lead, and Dondero answered to tie it up. A potential winning score for Dondero was called back and Kimball had raced to the Oaks' eight-yard line when the referee's gun sounded the end to a thrilling, exhausting 14-14 tie. (Dondero Oak, 1967.)

```
427P EST NOV 22 66 DEA364
DE LLV321 PD TDDE ROYALOAK MICH 22 334P EST
IVY LOFTIN, FOOTBALL COACH DONT FONE DLR ABT 630 PM
   DONDERO HIGH SCHOOL 709 NORTH WASHINGTON ROYAL OAK MICH
CONGRATULATIONS TO YOUR TEAM COACHING STAFF AND YOURSELF ON
YOUR FINE SEASON: BORDER CITIES CHAMPIONS AND STATE RANKING
   KIMBALL COACHING STAFF
(27).
```

After the 1966 Oak Stump Game, Kimball's coaching staff sent this telegram to coach Ivy Loftin, congratulating Dondero's 8-0-1 season that ended in a 14-14 tie with Kimball. The rivalry on game day was fierce; the respect the two schools had for each other was undeniable. While Loftin tried to ruin every Kimball football season, he sent his three daughters to Kimball. Said Melinda Loftin of attending Kimball, "I was so very proud to be a Kimball cheerleader but I might have been the only one who was happy no matter who won the game. Those were the best games anyone could hope for." (Ivy Loftin collection.)

In 1969, Kimball, undefeated and ranked No. 2 in the state's Associated Press rankings, awaited Dondero. Pictured above is the play that crushed a dream for Kimball, Dondero's two-point conversion that gave the Oaks a stirring 8-6 upset for the ages. In 1975, the first year of playoffs, Kimball returned the favor when the Knights stunned top-ranked and undefeated Dondero 20-19 by stopping the Oaks on the game's final play from the Kimball goal line. (Kimball Lancer, 1970.)

Playing the Oak Stump Game could be a head-turning experience for players and fans alike. Here a Royal Oak Kimball defender is turned upside down after a bruising block administered by a Royal Oak Dondero back in the 1979 game at Kimball. Coming into this game Dondero was 7-1 and champion of the now-defunct Metro Suburban Athletic Association (MSAA) in 1979 while Kimball was an uninspiring 4-4. Nonetheless, Kimball took down the Oaks in a 27-7 triumph. (Kimball Lancer, 1980.)

Kimball quarterback Burge Young lets it fly in the 1980 Kimball-Dondero game, a 13-6 Kimball win. Young marched Kimball to 21 consecutive wins, two SMA titles, and two grueling wins over rival Dondero. Notice Dondero's defensive end closing on Kimball's quarterback. To the left, a Kimball running back is being dumped, while further to the left, a Kimball receiver is delivering a forearm shiver. (Daily Tribune/Craig Gaffield.)

Dondero's 1980 season produced an uninspiring 4-5 record but the Oaks welcomed Kimball with a bruising desire to ruin their rival's unblemished season. Above an injured Kimball player is carried off the field while 10,000 fans have moved on to the next play. Kimball staged a goal line stand late in the fourth quarter to escape with a 13-6 victory in 1980. However, as first suffered by the 1976 Oaks, undefeated meant excluded as Kimball was left off the MHSAA playoff list two days later. (Daily Tribune/Craig Gaffield.)

In 1981, the "Battle Royal" was played in front of 10,000 fans at Kimball. Fans huddled around end zone fences, excluded from already-packed stands an hour before the game. Both schools were undefeated and league champions. When Kimball's Gary Adams raced 42 yards for a score in the fourth quarter, Kimball had earned a 17-7 victory, a school-record 21st straight win, a bid to the MHSAA playoffs, and the state's No. 1 ranking. (Kimball Lancer, 1982.)

Warren De LaSalle's Chuck Phares runs to glory and a six-point score in the 1991 Harper Woods–Notre Dame game at Notre Dame. The Pilots won this game over Notre Dame 33-7. After 50 years of football, Notre Dame played their last season in 2004 with an enrollment of 724 boys. Notre Dame's football legacy is best remembered for the 22 winning seasons, 16 consecutively, the school posted from 1957 to 1979. (De LaSalle High School archive.)

Duane Nelson hugs the Oil Can after Detroit De LaSalle defeated its archrival, St. Joseph's, on September 25, 1959, by a count of 13-0. Their rivals dating back to pre–World War II, St. Joe's last played De LaSalle in 1962 and closed in the spring of 1964, when its student population was merged with that of De LaSalle. Until the early 1980s, De LaSalle remained nestled on Detroit's east side near Connor Avenue, just blocks from the city airport, thus the school's nickname of Pilots. (De LaSalle High School archive.)

The Oil Can Game was a gritty affair that often pitted families of neighboring Detroit communities against one another for one night a year. This is a photograph from the De LaSalle yearbook of the 1959 game. After St. Joe's closed and merged into De LaSalle in 1962, the Pilots remained rivals with Harper Woods Bishop Gallagher and Harper Woods Notre Dame. Today only De LaSalle remains, and they are a staple of the Catholic League's Central Division. (De LaSalle High School Library.)

De LaSalle's John Vitale fights off a rugged block in his attempt to get to Bishop Gallagher's ball carrier in De LaSalle's 35-0 win in the 1983 game. Called the Propeller Game, Gallagher and De LaSalle last played in 2001, a 25-21 Gallagher win. Bishop Gallagher advanced to the MHSAA tournament semifinals in 1999 and 2001 and lost the championship game in 1992 and 1998. Gallagher closed in the spring of 2002. (De LaSalle High School archive.)

In 1983, De LaSalle shut out Harper Woods Notre Dame, 9-0, one of three shutouts for the Pilots 8-1 team, their only setback a 7-3 heartbreaker to Birmingham Brother Rice. After topping Detroit Cooley and Alpena, the purple and gold also got past Detroit Catholic Central and Southgate Aquinas in the season's final game. Sadly, this campaign was before the MHSAA expanded their playoffs in 1985, and the Pilots missed the tournament despite their excellent ledger. (De LaSalle High School archive.)

6

FARMINGTON HILLS HARRISON

A single word that best describes Farmington Hills Harrison football is unrivaled.

Since 1976, when Harrison played in their first championship game at the Pontiac Silverdome (a 36-27 loss to Midland Dow), the Hawks have enjoyed success beyond any other area school. Harrison has captured 12 MHSAA championships and has competed in the title game 16 times in 36 seasons. Harrison has been witness to 22 seasons of 10 wins or more and only four losing records.

Harrison has had rivals. Neighboring North Farmington High School was an early thorn in Harrison's side when the school opened in 1970. North Farmington was coached by hall of famer Ron Holland, who mentored the only coach Harrison has known, John Herrington. Westland John Glenn's Rockets, coached by Chuck Gordon, was a main deterrent to Harrison's high hopes. Chuch Apap and Walled Lake Western provided Harrison their stiffest competition in the 1990s. Since joining the OAA in 1998, Harrison is challenged annually by Clarkston, Lake Orion, and Rochester Adams. Detroit's St. Martin DePorres captured 12 MHSAA titles from 1978 to 2004, when the Catholic League school closed. The Eagles accomplished this in the state tournaments after competing in the rugged Catholic League.

North Farmington ended the 1970 season ranked No. 1 in class as a unanimous choice with 90 total points, but that was before there was a sponsored playoff. Westland John Glenn, with many strong teams and a 1993 championship game appearance, only managed five wins against eight losses when pitted with Harrison in the 1970s and 1980s. Walled Lake Western won championships in 1999 and 1996 and was a runner-up in 1992, yet Harrison owns a 29-3 mark all-time versus Western. Troy won there in 1994 and was the runner-up to Traverse City in 1985, but the Colts are 0-5 versus Harrison all-time.

Only the OAA's upper division has challenged Harrison. Harrison is 8-9 versus the Oakland County trio of Rochester Adams, Lake Orion, and Clarkston through 2007. The Highlanders of Rochester Adams own a state championship in 2003, several other playoffs wins, and a 4-2 mark against Harrison.

Yet Harrison has won 25 league titles, has ranked in Michigan's Associated Press Top Ten final poll 25 times, has 12 state titles, and 16 appearances as a finalist in the championship game. Add eight rankings as the unanimous No. 1, and Harrison is the only choice as metro Detroit's most successful football program.

In 1976, Harrison High embarked upon the first of 19 straight winning seasons, here handing their rivals from North Farmington a 21-0 loss. Coach John Herrington and the Hawks would go on to play in their first of 16 MHSAA title games, losing to Midland Dow 37-26. North Farmington went 19-2 in 1977–1978 and played Traverse City for the 1978 Class A championship, losing 20-14. (John Herrington collection.)

In 1976, Harrison was the beneficiary of "the catch," a touchdown late in the 1976 Class B title game versus Midland Dow High. Although Harrison went 8-1 in 1975, the first year of a championship tournament, Harrison was excluded. Making the title game was an indication of things to come for Harrison even though victory escaped the Hawks on this day. Despite the great grab, Harrison went down 37-26 to Dow's Chargers.

Rewarded for an outstanding season in 1976, the Hawks went from just another Oakland County varsity football team to championship contenders, a title Harrison High School has yet to relinquish since. (John Herrington collection.)

John Herrington (third from left) and his staff are seen during Herrington's salad days in 1976. Herrington was mentored as a young coach by Ron Holland, who had tremendous success at rival North Farmington, including winning 1970s mythical state title. Following the No. 1 ranking from the Associated Press in 1970, Holland's Raiders beat Herrington's Hawks three straight years from 1971 to 1973. After the Hawks first got to the title tilt in 1976, they would not return until 1981. (John Herrington collection.)

Harrison's success in 1976 in reaching the MHSAA's Class B title game brought heightened expectations in 1977. Here the Hawks traveled down Orchard Lake Road to face Farmington's Falcons. Farmington welcomed Harrison, fresh off a 10-win season, with a 20-19 setback to open the 1977 season for both schools. It would be one of the rare seasons that Harrison dropped both Farmington rivalry games, also dropping a 17-10 decision to North Farmington. (John Herrington collection.)

Playing Marysville High in front of a sold-out throng, this touchdown gives Harrison a 23-6 lead in the fourth quarter over the Vikings in this 1981 playoff game. Harrison would go on to win this game 23-13 and then shut out Ypsilanti's Willow Run Flyers (36-0) and Muskegon Catholic Central (7-0) in the Silverdome to capture the first of a record 12 MHSAA football titles. (John Herrington collection.)

One state football legend congratulates another in this letter from Michigan State University coach Frank "Muddy" Waters to Harrison's John Herrington. The Hawks advanced to the Class B semifinals in 1980, losing a 7-6 heartbreaker to Okemos High. Muddy Waters coached Hillsdale College to national NAIA prominence, pioneered the start of the program at Saginaw Valley State University in the mid-1970s, and coached the Michigan State University Spartans for three seasons. (John Herrington collection.)

MICHIGAN STATE SPARTANS

November 5, 1980

Coach John Herrington
Farmington Harrison High School
Farmington, MI 48018

Dear Coach Herrington:

Congratulations to you, your team and staff for a tremendous season.

The **"Spartans"** wish you well in your quest for the **State Championship!**

Sincerely,

Muddy
Frank "Muddy" Waters and the
M.S.U. Football Staff

Playing in a 100-yard mud pit, Harrison's Dave Blackmer kicks the game-winning field goal for Harrison in 1982's Class A MHSAA semifinal. After this 6-3 triumph over White Lake Lakeland, Harrison topped Dearborn Fordson for the Class A 1982 title. It would take 25 years for the Eagles to win another playoff game, when they defeated Walled Lake Western in 2007, but again, the Eagles were dropped by Harrison the following week, 33-22. (Observer and Eccentric/Doug Bauman.)

Harrison kicker Dave Blackmer was the thorn in the opponent's side two weeks in a row in 1982. Here Blackmer breaks the hearts of Dearborn Fordson in the Pontiac Silverdome, kicking the game-winning field goal in Harrison's 17-14 Class A title win over the Tractors. In both city and suburban leagues, fans today still see the occasional straight-on kicker that has disappeared from professional and major collegiate football. (Oakland Press/Rolf Winter.)

Chuck Skinner's Seaholm Maples dragged Farmington Hills Harrison through the mud in this 1984 MHSAA playoff game, but it was the Hawks who emerged victorious, 17-6. From 1982 to 1984, Seaholm's Maples won three consecutive Southeastern Michigan Association titles and went a cumulative 26-3 but lost in 1983 to neighboring Birmingham Brother Rice and dropped this opening-round game to Harrison. (John Herrington collection.)

Harrison linebacker John Miller stands alone as Harrison battles the elements and Birmingham Seaholm in 1984's opening round of the Class A football tournament. Miller went on to be a stalwart defender for coach George Perles at Michigan State University. Many former Harrison Hawks over the last 20–25 years have beaten a path from the dominant high school on Twelve Mile Road to Michigan State University's East Lansing campus. (John Herrington collection.)

The Rockets of John Glenn were one of the few schools in metro Detroit to stare down Harrison with any success in the 1980s, going 5-7 all-time versus the Hawks. This was Glenn's eighth-consecutive victory of 1985, a 28-7 win. In 1985, coach Chuck Gordon's Rockets were an undefeated 9-0 and advanced to the MHSAA playoffs, where the Rockets lost to eventual Class A finalist Ann Arbor Pioneer, 33-20. (John Herrington collection.)

After defeating Marysville, an opponent the Hawks met three times within seven seasons, the victors celebrate a 35-20 win leading to the 1987 MHSAA championship game. Notice the team's manager, in the white Harrison jersey, in the bottom of the picture. Coach John Herrington and his players picked this Harrison student to be manager because of his loyal spirit and effort. It is something Herrington gets little credit for publicly, his acceptance of all who represent his Harrison football family. (John Herrington collection.)

A familiar sight since 1975, Farmington Hills Harrison is in the MHSAA championship game. The Hawks have played in 16 championship games and have captured 12 of those contests. Harrison's winning percentage of .817 is tops among all Michigan high schools that have played at least 100 games. The Hawks' all-time record is a staggering 350-78-1, including an incredible 75-13 playoff ledger. (Observer and Eccentric.)

METRO DETROIT'S HIGH SCHOOL FOOTBALL RIVALRIES

Farmington Hills Harrison's winning tradition makes the inclusion of the Hawks on any school's schedule that squad's red-letter game of the season. Here Harrison battles conference foe Livonia Franklin High in 1992, one of only two losing seasons for Harrison since 1972 (the other was in 2004). Since 1980, Harrison has won at least 10 games in 21 of 28 seasons. Harrison went 45-3 from 1987 to 1990, 35-1 from 1996 to 1999, and won 36 straight games from 1999 to 2002. (Observer and Eccentric.)

Perhaps two of the most dynamic teams to ever represent Harrison High played in the 1988 and 1989 seasons, when Harrison went 13-0 in each season. The Hawks were led by a versatile ground game that featured all-purpose quarterback Mill "the Thrill" Coleman (left) and punishing halfback Joe George. The Hawks ran over their competition in 1988, including 11 wins of 30 points or more. Only Southfield High came closer than 15 when the Blue Jays dropped a 25-12 opener. (Observer and Eccentric/Randy Borst.)

Harrison's Mill Coleman attacks the Riverview High defense during a 23-7 playoff win over the Pirates in Harrison's 1989 championship season. After an all-state career at Farmington Hills Harrison, Coleman accepted a scholarship offer to play for Michigan State University. Coleman was but one of many Harrison Hawks who traded the green and gold of Harrison for Michigan State's green and white. (Observer and Eccentric/Randy Borst.)

Fraser's Ramblers became collateral damage of Harrison's 1993 Class A championship train when Harrison took this 35-14 playoff decision from the longtime Macomb Area Conference member. Fraser played for the Class A title in 1981 after upsetting No. 1 ranked Royal Oak Kimball and defeating Detroit PSL champion Detroit Cooley in the MHSAA semifinals. The Ramblers dropped a 16-6 decision in the Silverdome to Escanaba High's Esykmos, who hail from Lake Michigan's lakefront in the state's Upper Peninsula. (Observer and Eccentric.)

7

MACOMB COUNTY

Macomb County's football lineage is one of traditional inner-city battles and teeming high schools that always have a stake in the state's football championships.

In the city of Warren, there was a period when the public school system was so big, every city high school played six of nine games a year without leaving Warren's city borders. Warren Woods and Warren Tower merged into Woods-Tower High School and Warren High's Orioles ceased after 1991. Today Warren Cousino and Warren Mott are big rivals, as are Warren Fitzgerald and Warren Lincoln. The Catholic League's De LaSalle Collegiate High relocated from Detroit to Warren in the early 1980s.

The county lays claim to three Brown Jug Games. Center Line, once called Busch High School, and Warren Lincoln have played a trophy game for over 60 years. Peach farms dominate Romeo in the spring and summer but winning the Brown Jug Game, played with neighboring Utica High School 57 times since 1934, is the focus in the fall. Port Huron's Big Reds and Mount Clemens's Battling Bathers have dueled for a Brown Jug in two classic memorial stadiums.

Finally, Macomb County's premier games come from the Macomb Athletic Conference's Red Division, a cluster of schools that rival the O-K Conference from the west side of the state; the Catholic League's Central Division; and the OAA's top four schools in Oakland County for bragging rights in state football circles.

Utica Eisenhower and Sterling Heights Stevenson have waged fierce battles since 1980. Mount Clemens Chippewa Valley was already a powerhouse when Macomb Dakota opened in 1996. Chippewa won a title in 2001 while Dakota has been back-to-back champions in 2006 and 2007. The game between the two schools has been the must-win contest for each school. L'Anse Creuse and L'Anse Creuse North stage a spirited game every year and Utica Ford and Utica High make M-59 the dividing line for bragging rights on a yearly basis.

The Macomb Athletic Conference (MAC) also houses Grosse Pointe North and Grosse Pointe South, even though both schools are located in Wayne County proper. Until Dakota won back-to-back championships, MAC schools were among the best not to win a title. Stevenson made the finals in 2004 and 1996, while Eisenhower was runner-up in 2003, 2001, 2000, and 1999. While it does not equal winning the championship it is a strong indicator of the quality of play and excellent records put forth by Macomb County's finest players and coaches.

Utica High receiver Michael LaLone played in the last Brown Jug game won by Utica, a 2003 victory over Romeo by a 32-7 count. LaLone helped design Utica's current uniform, still used by the Chieftains today. Romeo High has won 24 of the previous 30 contests since 1975. Before that the Chieftains took 16 of the previous 23 games not ending in a tie score. (Utica Chieftain, 2004.)

Victory achieved and Brown Jug secured, the Chieftains enjoy a victory meal at Utica High in 1956. Undefeated in their eight previous games, the Bulldogs ran into a buzz saw that ripped through their defense in an unexpected 27-0 Utica victory. It was the first season the Bulldogs were not coached by Dan Barnaboo. From 1950 to 1975, the Chieftains went 16-7-3 in games between the two rivals, who will meet for the 58th time on October 24, 2008. (Utica Chieftain, 1953.)

Chieftain halfback Bob Arft heeds the advice from Utica head coach Bob LaParl in this 1952 home game versus Romeo. The Chieftains ran the table in a dominating, undefeated campaign of 1952. Utica High outscored its opponents 266-38 en route to the Bi-County League title. Utica's 53-6 margin of victory in this 1952 tilt remains one of the largest margins of victory either team has tallied on the other. (Utica Chieftain, 1953.)

When current Utica High athletic director Karyn Holmes prepared for her first Brown Jug Game in 2004, she knew of the trophy's importance: "The day of the game, I pulled it out of the trophy case and didn't let it out of my care." Over the history of the Little Brown Jug game between Romeo and Utica, the Bulldogs hold a 30-22 margin in 57 games. Four times the game ended in a deadlocked score.

METRO DETROIT'S HIGH SCHOOL FOOTBALL RIVALRIES 89

Clarkston High and Utica Eisenhower have met five times since 1999 when Ike took a 14-9 playoff win. The Wolves have a 3-2 mark versus Ike's Eagles, who also claim Utica High and Sterling Heights Stevenson as main rivals. Ike, as well as Stevenson, is among a handful of schools with outstanding success void of a state championship. Ike went to the MHSAA finals in 2003, 2001, 2000, and 1999, while Stevenson was runner-up in 1986, 1996, and 2004. (Tim Busch Sports Photography.)

Mount Clemens Chippewa Valley and Macomb Dakota remain each other's chief rivals as they battle in the second round of the 2006 MHSAA tournament. The Big Reds, pictured above in white, won the MHSAA's Division I title in 2001 and advanced to the semifinals in 2000. The rivalry was ignited when Dakota ousted Chippewa in the 1999 playoffs after dropping a 28-14 regular season decision, the schools' first meeting. (Tim Busch Sports Photography.)

Macomb Dakota kicks the winning field goal past the outstretched arms of the Clarkston High Wolves in 2006's Division I Regional championship game at Dakota. Opened in 1996, the Cougars have become the dominant east side high school program of late. After losing 17 of its first 18 contests, Dakota has gone 87-30 since, including an astounding 37-4 in the past three seasons. Dakota won the 2006 and 2007 MHSAA Division I championship and advanced to the MHSAA semifinals in 2005. (Tim Busch Sports Photography.)

There has not been a game in the MAC's Red Division that was not a top-flight football game for the past 20 years. Here Utica Eisenhower and Macomb Dakota battle in the 2006 playoff opener, won by Dakota, 3-0. Six MAC rivals, including Ike, Dakota, Mount Clemens Chippewa Valley, Sterling Heights Stevenson, Utica Ford, and Utica, battle each other every season, making the MAC one of Michigan's toughest leagues statewide. (Tim Busch Sports Photography.)

The 1970 Warren Lincoln Abes admire the season highlight, capturing the Brown Jug from rival Center Line. Ironically, Center Line's former name, Busch, is still seen on the jug today. In the 1940s, fights cancelled the game between Busch and Lincoln. After the high school was renamed, the athletic directors from each school agreed it was important to bring the game back. Here the team celebrates the Abes' 14-2 win, their first win over Center Line in four years. (Lincoln Commander, 1971.)

In this Brown Jug contest, the Panthers (in white) have forced the Abes into a punt formation on fourth down of the first possession of the 1973 game. Lincoln went on to post a 15-0 win in this game. Until 2006, when the schools decided to meet in the last week of the regular season for each school, the game's scheduling could be any one of the nine weeks of the season. (Lincoln Commander, 1974.)

In 1966, the Brown Jug Game was played on September 23. Here Lincoln's coach advises his team's captain to remain composed despite early Panther success. Center Line jumped to a 6-0 lead but succumbed in a 20-6 defeat. The Panthers were 5-3 in 1966, while the Abes went 3-4-1 competing in the now-defunct Bi-County League. Due to scheduling difficulties, from 1960–1972 Center Line only played eight games; Lincoln played just eight games from 1959–1973, save for 1969. (Lincoln Commander, 1967.)

The look of despair is painted across the Abes' sideline as Lincoln watches the Panthers finish a hard-fought 13-6 win in the 1967 Brown Jug Game. The Panthers went undefeated in this season, earning a 34-7 win over Sterling Heights Stevenson and a 59-13 thrashing of Warren Cousino, becoming the champion of the Bi-County League. The only blemish on the Panthers' ledger of 1967 was a 13-13 tie with the Spartans of Warren Fitzgerald High. (Lincoln Commander, 1968.)

METRO DETROIT'S HIGH SCHOOL FOOTBALL RIVALRIES

Coach Clinton "Barney" Swinehart (left) discusses the proper technique to grib and throw the football with Utica High's quarterback and Chieftain captain Pat Conner. The Utica Community Schools named the school's football field at Shelby Road and 21 Mile Road for Swinehart on September 15, 1989, and Romeo added to the rivalry by spoiling the game for the Chieftains with a 10-6 win. The stadium is shared by Utica and the rival Eagles of Utica Eisenhower High. (Utica Chieftain, 1953.)

Tony Angel and Chuck Faulkner, Bi-County All-League selections.

Schedule	Utica	Opp.
Rochester	36	6
Lakeview	28	14
South Lake	21	7
Centerline	0	27
Warren-Lincoln	6	28
Lake Shore	12	14
Fraser	14	21
Warren	0	35
Romeo	18	20

Utica High footballers Tony Angel (left) and Chuck Faulkner were Bi-County League selections in 1954. Utica High left the now-defunct Bi-County League in 1967, which folded for good in 1986, but letter sweaters, as shown in this picture, went out of style long before then. Today high school letter winners are usually adorned in only a varsity jacket, as opposed to the optional button-up or pullover sweaters from the car-hop era. (Utica Chieftain, 1955.)

Center Line and Warren Lincoln have enjoyed a rivalry as evenly contested as Brother Rice and Catholic Central. While no one would argue the Panthers and Abes to be the caliber of the aforementioned parochial giants, the two Macomb County rivals have each won 29 of the past 58 Little Brown Jug Games dating back to 1950, and the series goes back further than that. Here Lincoln's Abes storm onto the field with the prized trophy secured. (Lincoln Commander, 1974.)

Unlike collegiate and professional football, high school football's procedural protocol remains unchanged after nearly 60 years. Here a Utica High gridder comes off the bus in a game around 1951. Today prep football teams still dress at their own school and take the bus ride to the opponent's field. Many a prep player will recount the quiet ride before the storm, as well as the jubilant elation of a win or the deafening quiet of a loss. (Utica High archives.)

METRO DETROIT'S HIGH SCHOOL FOOTBALL RIVALRIES

Romeo's Bulldogs held Utica's Gordon Schwartz inches short of the goal line in the waning moments of this 20-18 defeat of Utica High at what would later become Dan Barnaboo Field, Romeo's home stadium. Although unconfirmed in official records, it is believed this game took place in 1951. The Bulldogs have been one of Macomb County's better programs in the last decade, going 46-24 since 2001. (Utica Chieftain.)

Bearing down on Utica quarterback Tom Orlowsky is Romeo's Frank Czajka in Romeo's 25-0 blanking of the Chieftains in the 1957 Little Brown Jug Game. Surely revenge was a high priority in this game for the 'Dogs, who watched a potential perfect season go up in smoke in 1956 when Romeo's undefeated bandwagon rolled into Utica. Four quarters later, it was Utica who had smoked the Bulldogs 27-0, a game Romeo certainly remembered in handing Utica this defeat. (Utica Chieftain, 1957.)

8

Playoffs, Championships, and All-Star Games

The high school football playoff structure in Michigan has been hotly debated since 1975. Before then, Michigan's state football champion was declared by a metropolitan newspaper or the top-ranked school in the Associated Press Top Ten poll. Naturally this was a point of consternation for many coaches, players, administrators, and fans. One can still visit metro-area schools today with banners hanging in gymnasiums exalting their school as the mythical state football champion in years prior to 1975.

In 1973, after heavy lobbying done by the Michigan High School Football Coaches Association, a playoff structure was introduced to decide a champion on the field. Jeff Smith, a math teacher and football coach from East Lansing High School, was a key asset in devising a mathematical formula rewarding victories and wins over another school with a winning record. After the mathematical formula was approved, a "paper playoff" was conducted in 1974. Hazel Park High School was one of the top-ranked teams to make the field that season—on paper—because 1974 would be the last season without a playoff.

In 1975, Hazel Park's Vikings were not even close, not that close mattered. In the first two years of the playoff, only the top-ranked school in four regions in each of the four classes qualified for the playoff. That is four per class and 16 schools total out of more than 600 offering football. In 1977, the field doubled to eight per class (32 qualifiers) and in 1985, the numbers doubled again to 16 per class, 64 total playoff qualifiers.

In the first 10 years of playoffs, there were enough undefeated and one-loss schools missing the playoffs to host a tournament exclusively for the jilted and excluded. Recognizing this, the MHSAA in 1990 split the classes from four to eight, doubling the field to 128 schools per year. In 1999, the current formula of 256 qualifiers pared from eight divisions based on the enrollment of over-600-member schools offering football was adopted.

The state's coaches' association hosts the East-West All-Star game at Michigan State University's Spartan Stadium. Coaches nominate deserving players for a game played annually, usually in the third weekend of July.

Royal Oak Dondero played its first-ever playoff game, a 35-12 loss to Jonathon Burtran (above) and Birmingham Brother Rice, the Class A champion of 1990. Dondero went 113-45-3 from 1965 to 1982, had three undefeated seasons and five campaigns with eight wins but never qualified for the playoffs. The Oaks lost 13-0 in a first-round home game to Fraser High in 1991 and never returned to the tournament (Daily Tribune/Craig Gaffield.)

It was elation for Detroit Catholic Central and disappointment for the men of Troy after the last play of the Shamrocks' 22-19 win on November 13, 1998. Troy's teams from 1984 to 1999 were as dominant as any in the metro area, going 134-32 but the Colts were stymied by Catholic Central. Meeting five times during that period, Troy only managed a win in 1985. Troy advanced to the title game in 1985 and 1994 and captured 1994's championship. (Observer and Eccentric/Stephen Cantrell.)

Catholic Central put the 1998 MHSAA district championship in the books with this touchdown run in the fourth quarter of a 22-19 win over the men of Troy High. Catholic Central sandwiched this hard-fought victory between an opening-round win over Dearborn Fordson and wins over Sterling Heights Stevenson and finally Rockford in winning the 1998 Class AA title, their third championship in four years. (Observer and Eccentric/Stephen Cantrell.)

Detroit Henry Ford fights Brother Rice in the 1983 Mud Bowl, an MHSAA Class A semifinal won by Rice 28-14. Detroit Henry Ford is among a select handful of schools to have exceptional teams but no state titles. From 1981 to 2007, Ford's Trojans have run up an impressive ledger of 190-76, with only one losing season (2003) that ended a string of 22 consecutive winning records. Ford has played 27 MHSAA playoff games but has only managed nine wins. (Observer and Eccentric/Stephen Cantrell.)

METRO DETROIT'S HIGH SCHOOL FOOTBALL RIVALRIES

With the clock reading triple-zeroes, Westland John Glenn exhales a celebratory sigh of relief after surviving the Railsplitters of Lincoln Park High in the 1998 MHSAA tournament opener. John Glenn put forth a handsome record for countless seasons but, like Detroit Henry Ford, victories in the biggest games have eluded the Rockets. In 1993, John Glenn got the MHSAA Class AA title game but dropped a 12-7 decision to a fellow rival school seeking their first title, Dearborn Fordson. (Observer and Eccentric.)

Despair and thoughts of what could have been filled the hearts of Westland John Glenn after dropping a bitter 27-21 contest to Birmingham Brother Rice in 1989's MHSAA tournament. The Rockets have qualified for the state tournament in 16 of the last 23 seasons, and advanced to the 1993 Class AA title game, but own a 17-16 record in playoff games. John Glenn remains among schools that have an excellent winning tradition without winning a state title. (Observer and Eccentric)

John Glenn threw everything it could against Brighton's Bulldogs in this 1998 MHSAA tournament game but came up short in a 17-14 loss. Brighton represented the physically demanding Kensington Valley Conference (KVC) well in 1998. After tying for the KVC title with Hartland, which won the head-to-head battle with Brighton, it was Brighton who advanced on this week after Hartland dropped their playoff opener to Farmington Hills Harrison 42-14. Lake Orion ended Brighton's season a week later by a 26-14 count. (Observer and Eccentric/Guy Walker.)

Another Kensington Valley Conference school with an outstanding tradition is South Lyon, who fought the good fight in a thrilling 28-26 loss to Farmington Hills Harrison in 1994. Many a KVC title was decided by teams representing Milford, Novi, Brighton, or South Lyon. Harrison survived this potential upset, defeated Royal Oak Kimball 38-25 in the Class A semifinals, and topped Grand Rapids Forest Hills Central 17-13 to capture the Class A championship of 1994. (Observer and Eccentric.)

Catholic Central ran around, over, and through Detroit Henry Ford in the 1991 quarterfinal 38-8 win en route to the MHSAA championship game, where the Shamrocks dropped a 13-12 decision to Saginaw Arthur Hill from the Saginaw Valley Association. In 1992, Catholic Central would avenge that one-point title game loss by defeating Arthur Hill 21-20. (Observer and Eccentric/Art Emanuele.)

Southeastern Michigan Association champion Birmingham Seaholm was turned upside down in the 1983 tournament opener with Birmingham Brother Rice. After marching undefeated to the playoffs by outscoring opponents 197-45, Seaholm struggled in this 21-6 loss to eventual MHSAA champion Brother Rice. The Warriors went 12-0 and defeated Henry Ford (28-14) and East Lansing (15-12) in the Pontiac Silverdome. (Observer and Eccentric/Gary Caskey.)

Birmingham Seaholm finally broke through against perennial power Brother Rice in 1993. This quarterback sack by Seaholm ended the comeback hopes of Brother Rice in the final quarter of the Maples' 14-13 win at Pontiac's Wisner Stadium. Rice uncharacteristically struggled in the mid-1990s versus public schools, dropping playoff games to Berkley in 1994 and Grosse Pointe North in 1996. (Observer and Eccentric.)

Longtime Catholic Central coach Tom Mach and his Shamrocks celebrate another MHSAA tournament championship in the Pontiac Silverdome. From 1990 through 2002, Catholic Central made the Silverdome their unofficial home, winning seven titles and making nine appearances in the title game. In 1990–1992 and 2000–2002, Catholic Central went to the title game in each season. (Observer and Eccentric/G. Warren.)

METRO DETROIT'S HIGH SCHOOL FOOTBALL RIVALRIES 103

Winning can produce elation but how one handles defeat can define their character. This Brother Rice Warrior cannot bear to watch the final plays of Rice's 14-0 loss to East Lansing High's Trojans in 1991. This title game loss in the Pontiac Silverdome was preceded by a Cinderella-like run to the title game for Rice after starting 0-2 and being 3-3 after losing the annual Catholic Central game. (Observer and Eccentric.)

John Burtran scores the clinching touchdown for Brother Rice in the fourth quarter of a 24-10 win over Midland High to win the 1990 MHSAA title in the Pontiac Silverdome. Rice's road to the 1990 championship came by going through metro Detroit. The Warriors defeated Royal Oak Dondero, Bloomfield Hills Lahser, and Northville High in the semifinal. (Daily Tribune/Craig Gaffield.)

After defeating Midland High's Chemics, Brother Rice takes the championship trophy to their faithful fans across the field. Since 1976, the state title has been hosted indoors at either the Pontiac Silverdome, host of Super Bowl XVI, or Detroit's Ford Field, host of Super Bowl XL. Quite by accident, the annual MHSAA championships replaced Thanksgiving Day traditions of high school football in many Michigan communities. (Daily Tribune/Craig Gaffield.)

Orchard Lake St. Mary's storms off the field while winning the 1977 Class B title game over West Iron County High. The Eaglets were a virtual scoring machine in 1977, outscoring all opponents by 486-103, marching to a 12-0 record. St. Mary's won the Catholic League by defeating Waterford Our Lady of the Lakes, then escaping Royal Oak Shrine 20-19 in the first round and Lake Michigan St. Joe's in the semifinal. (Observer and Eccentric/John Stano.)

METRO DETROIT'S HIGH SCHOOL FOOTBALL RIVALRIES

The Michigan High School Football Coaches Association hosts an annual all-star game at Michigan State University. The contest is staged around the third weekend in July and pairs the metro Detroit area as the East team and the rest of the state makes up the West squad. Member coaches nominate deserving players. (Daily Tribune/Craig Gaffield.)

The annual East-West All-Star game at Michigan State University's Spartan Stadium creates competition between college-bound seniors that otherwise would never face one another. Here a Brother Rice Warrior and a Holt Ram lock horns in the 1991 game. (Daily Tribune/Craig Gaffield.)

9

THE GREAT COACHES

Great coaching is measured not only but wins and losses, but the ability to mold young boys into young men while handling victory and defeat with dignity and grace.

Coaches hold a special place in high school football. It is not all about winning and losing, although no coach with a losing record has ever been called great. It is about teaching and commanding respect in equal doses. Capturing a state championship might make one a winner; not winning does not exclude one from the club. Michigan's High School Football Coaches Hall of Fame is chock full of men who never lifted a championship trophy but did lift young men from obscurity into letterman, graduates, husbands, and fathers.

Coaches make communities better. They are tough. They will punish a player and welcome them back in the same breath. They are a player's best friend when the player thinks they are their worst enemy. They dump a truckload of hours into a job they earn pennies per hour for. Some of the best coaches serve as loyal assistants. They make a defense stout or a group of linebackers fierce. They make sure the weight room gets opened, encourage a player to bring his grades up, or spend hours pouring over film and scouting next week's opponent.

It is the raspy voice of a man wearing a tattered ball cap; that is a coach. It is the pregame speech delivered with so much energy, the walk to the stadium tunnel seems like a march into history. So is the guy who has been at the school since the day it opened. It is the history teacher with the biggest set of hands anyone has ever seen. So is the guy who lines up without pads and shows his players how it is done; that is a coach.

Most of all, it is the man players tell their wives about 20 years after they graduated, the type of man they want to coach their boy, one as great as the one they had in high school. That is a football coach. There are the coaches of metro Detroit, who led young boys into gridiron battle and turned them into young men.

Joe Hoskins led the Trojans of Detroit Henry Ford for many an outstanding season. Here Hoskins and his Trojans are battling Birmingham Brother Rice in a Mud Bowl game that Rice won 28-14 in the 1983 MHSAA playoffs. Henry Ford is one of the few schools with an outstanding record and tradition despite not winning a state title. Hoskins passed away in 2006. (Observer and Eccentric/Stephen Cantrell.)

Ferndale High's Frank Joranko was successful on both the high school and college levels. After taking the reins of the already-successful program, Joranko's Eagles won the mythical Class A championship in 1972, and Joranko was selected as the Michigan High School Football Coach of the Year that same year. Joranko left Ferndale for Albion College in 1973 where he won MIAA titles in 1976 and 1977. (Daily Tribune.)

Clarkston's Kurt Richardson has led the Wolves for many years, bringing Clarkston to the forefront of one of the metro's biggest rivalries with Lake Orion High. Since joining the rugged OAA in 1994, Richardson's teams have tallied an impressive 107-41 record while facing annual powers like Rochester Adams, Farmington Hills Harrison, and rival Lake Orion. Richardson was inducted into the Michigan Coaches' Hall of Fame in 2008. (Oakland Press/Doug Bauman.)

The Catholic League director for more than a handful of years, Walt Bazylewicz cut his teeth from the sidelines as coach Bazylewicz. This 1990 photograph is from Redford Bishop Borgess, when the Spartans won an impressive 26-8 decision from perennial power Orchard Lake St. Mary's. The Spartans went 6-3 in 1990. In appreciation of his long tenure in many capacities, Bazylewicz is a member of both the Catholic League and Michigan Coaches' Hall of Fame. (Daily Tribune.)

Rick Brewer, shown here at a 1977 practice at Avondale High, ran the Yellowjacket sideline with much success from the late 1970s into the mid-1980s. Brewer's teams advanced to the MHSAA semifinals in 1988, won a handful of league titles, and qualified for several MHSAA tournaments. Brewer was inducted into the Michigan Coaches' Hall of Fame in 1998. (Oakland Press.)

Two of metro Detroit's most successful coaches shake hands after Tom Mach (left) and Detroit Catholic Central topped Chuck Gordon's John Glenn Rockets, 21-6. Mach led Catholic Central to nine MHSAA championships; Gordon reached the finals in 1993 but dropped a 12-7 count to Dearborn Fordson. Both men are members of the Michigan Coaches' Hall of Fame. (Observer and Eccentric/Steve Fecht.)

Birmingham Brother Rice's Al Fracassa (left) congratulates North Farmington High coach Ron Holland after Holland's Raiders snapped Rice's 24-game winning streak on November 17, 1978, in the Class A semifinal. Fracassa has earned five MHSAA championships with Brother Rice; Holland won the mythical 1970 Class A championship and was a finalist in 1978, dropping a 20-14 title game to Traverse City High. Both men are in the Michigan Coaches' Hall of Fame. (Observer and Eccentric.)

The toughest screw to ever walk the sideline at Birmingham Seaholm High was coach Chuck Skinner, who came to the posh community after a long and successful stint at Hazel Park High School. From the instant Skinner went to Seaholm, Hazel Park desired to beat their former favorite son, making that game an annual grudge match. Skinner was inducted into the Michigan Coaches' Hall of Fame in 1984, the year his Maples went 9-1. (Observer and Eccentric/Gary Caskey.)

METRO DETROIT'S HIGH SCHOOL FOOTBALL RIVALRIES

Known as I. L. at home, Iverson Loftin was coach "Ivy" Loftin for Royal Oak Dondero's first 27 seasons after serving as an assistant at Royal Oak High under Jim Manilla. Loftin went 151-79-8, captured 11 league titles, and his 1976 team went undefeated, earning him Michigan's Coach of the Year award. Loftin retired in 1983 after being inducted in the inaugural class of the Michigan Coaches Hall of Fame but returned to Dondero as an assistant under Fred Fuhr, helping Dondero to two more MSAA titles in 1986–1987. (Daily Tribune.)

"Better luck next season, coach," quipped one of Paul Temerian's players after Royal Oak Kimball's undefeated 1965—but there was no luck about Temerian, winning his 100th game in 1980 at Ferndale High. Temerian coached every Kimball game from 1957 until 1983, the first eight as an assistant until named head coach in 1965. Temerian went 131-39-1, won 10 league crowns and earned five rankings in the Associated Press's season-ending poll. Temerian coached eight more seasons at Rector (Arkansas) High, including the first seven winning seasons since 1970. The city's trustees named the school's field for Temerian after he passed away in 2004. (Daily Tribune/Craig Gaffield.)

Jack Reardon, shown here in a 1986 game, was better known as "Gentle Jack" when he coached the Spartans of Livonia Stevenson. "I remember he had the paws of a bear but he was the most gentile man I ever interviewed," said reporter Brad Emons of the *Observer and Eccentric* newspapers. "Every night that we couldn't send a reporter or photographer to Stevenson's game, we would come by the newsroom to give us the details." Reardon was inducted in the Michigan Coaches' Hall of Fame in 1985. (Observer and Eccentric/Art Emanuele.)

John Herrington's been the only coach Farmington Hills Harrison High School has ever known, and according to Herrington, it is not going to change anytime soon: "I figure I've got about another 10 years in me." Herrington's legacy is as secure as Fort Knox—he is the dean of Michigan's high school football coaches. Harrison's 12 MHSAA championships, 16 appearances in the title game, and winning percentage of .817 since 1970 is a legacy even legends dream about. (Observer and Eccentric.)

Frank Stagg wore No. 38 as a Hazel Park Viking but he came back to his alma mater to follow a legend. When Chuck Skinner left Hazel Park for rival Birmingham Seaholm, the Vikings were left rudderless. Enter Frank Stagg, serving first as an assistant and later a head coach, Stagg returned the grit, fight, and determination that had indemnified the Hazel Park program for so many years in the 1960s and 1970s. The Vikings' winning ways returned as well. (Daily Tribune/Craig Gaffield.)

Jim McDougall did not need to coach anymore to prove himself when he took over Berkley High three years ago. He has been around. He was the man at Royal Oak Shrine when the Knights battled Divine Child and Bishop Foley. He went to Birmingham Groves, pulled the Falcons out of the mud, and made Groves an annual league contender. Berkley High lured this bear out of the den to teach the Bears how to claw and fight to victory. McDougall entered the Michigan Coaches' Hall of Fame in 1989. (Daily Tribune/Craig Gaffield.)

THE GREAT COACHES

Before coming to Birmingham Seaholm, Doug Frasor had already made a name for himself at Lake Orion High School, where the Dragons went from a small lakes-area town to a teeming Class A contender. Here Frasor coaches Seaholm to a dominating 27-6 win over Royal Oak Kimball in a 1987 game at Seaholm. Frasor had another tough task: follow Chuck Skinner at Seaholm, but Frasor kept the Maples on track with several winning seasons. (Observer and Eccentric.)

Catholic League graduate Joe D'Angelo made his mark in high school football as the coach at Detroit Country Day. Here D'Angelo accepts the MHSAA championship trophy in 1986 after his Yellowjackets defeated Muskegon Catholic Central 18-14 at the Pontiac Silverdome. Country Day also took 1995's Class B championship while making the finals in 1994 under D'Angelo, who was 161-47. The Yellowjackets saw their tradtion of playing fellow private school and Catholic League rival Orchard Lake St. Mary's end in 2005, a game that was played nearly every season since 1976. (The Daily Tribune/Dick Hunt.)

Darrel Schumacher had a knack of taking the team with the least and making it achieve the most, which many of his Northville teams did. Among the many quality seasons he coached the Mustangs to, it was the handful of upsets Northville handed rival Novi High in the annual Baseline Jug Game, shown here in 1990. His counterpart at Novi, John Osborne, made the Baseline Jug Game a must-see game in the 1980s and 1990s. (Northville Palladium, 1991.)

Many know Albert Fracassa for his five state titles at Birmingham Brother Rice. Few remain to recall Fracassa's days as Royal Oak Shrine's top decision maker. Here Fracassa preps his team at halftime in the MHSAA's Class A championship game of 1980 at the Pontiac Silverdome, a game Rice won 6-0 over Dearborn Fordson when Rice passer Dave Yarema found Paul Jokisch for the game-winning touchdown. Yarema played for Michigan State University; Jokisch played for Michigan. (Daily Tribune/Craig Gaffield.)

10

WE'VE GOT SPIRIT

Unless one has smelled the grass, felt the chill in the air, and experienced the elation and disappointment of high school football they might wonder why metro Detroiters still make high school football a priority.

Coming out to the high school to watch varsity football is a rite of passage in metro Detroit. It is watching a neighbor's son or the girl from church. It is students supporting fellow students, or students just out for a rowdy time. Either way there is a place for everyone. It is grandparents and elders of the community who make their way to the stadium with folding chairs and a wealth of knowledge, able to recite the time when the home team's touchdown was called back because of a holding call, still dismayed by the call 40 years later.

It is the pint-sized press boxes and assistant coaches who volunteer to coach the young men and women in the schools. It is a math teacher who coaches the defensive backs and the head wrestling coach who coaches the lineman in the fall.

It is the local paper and the prep sports reporter who covers the game and keeps everyone interested in reading about the high school sports scene. These reporters are not covering nationally televised games but are covering the games that will be remembered for years and years to come. Think about it—one might not be able to remember who won the Super Bowl each year but everyone can remember if their school won its rivalry game senior year. Finally, it is a player waking up on a Saturday and finding their picture on the front of the sports section after their team's big win, thanks for a photographer who captured them at the right place and the right time.

Friday night football is special. It is special because it is a unique combination of adults and kids making a night at the school feel unique and worthy of everyone's best efforts. The coaches and administrators, who let the players have some ownership of their school's results, were preparing them, in part and parcel, for a life after high school.

It is just a game, but for many who could not play football, it was their way to be part of the Friday night.

This program cover from the 1950 game between Hazel Park and Warren Lincoln captures the spirit of high school football in post–World War II Detroit. The student print shop would typeset the inside of the program, including rosters and picture captions while the cover and inside would be farmed out and a sponsor, like Coca-Cola, would splay their art behind the rosters. Also notice "Lincoln–Van Dyke," which was Warren Lincoln and not to be confused with Ferndale High, also called Lincoln. (Hazel Park High School archive.)

The WJBK Prep Athlete of the Week is interviewed on live television at WJBK's Southfield studios. This identified athlete is from Dearborn High and sits left of the talent during this 1956 production. Prep sports has seen most of its publicity generated within internet chat rooms and recruiting sites in the present day. In the 1950s, a local prep athlete being interviewed would be cause for an entire neighborhood to stay home and watch the local boy's fleeting minutes of fame. (Lil' Café, Dearborn.)

WE'VE GOT SPIRIT

EDSEL FORD H. S.
"Thunderbirds"

Support Your School

School spirit was encouraged and expected in the 1950s and 1960s. This poster, from Dearborn Edsel Ford High, was posted in local Dearborn restaurants, barbershops, libraries, and diners by the Edsel Ford Varsity Club. The varsity club is a staple still today at most high schools, a club for letter winners to promote the positive in high school sports. (Lil' Café, Dearborn.)

The Pep Jug from Northville High was pictured in the school's 1964 yearbook, the *Palladium*. The school's traditional rival of the last 40 years, neighboring Novi High, was not even proposed when this picture was taken. Almost all schools played a football game with a rival for a trophy. It is not known if this jug became the Baseline Jug, a trophy that was stolen and later replaced by the *Novi News*, the local paper that covers the Northville Mustangs and Novi Wildcats. (Northville Palladium, 1964.)

METRO DETROIT'S HIGH SCHOOL FOOTBALL RIVALRIES

The pride of entire towns could come down to the local school's annual football game with neighboring communities. Perhaps no facility in metro Detroit has hosted more of these games than Pontiac's Wisner Stadium. Pontiac High's annual game with Saginaw High, when both schools competed in the rugged Saginaw Valley Conference, was always one of the biggest games of the year for the Chiefs, who later became Pontiac Central High when Pontiac Northern opened in 1959. (Bill Davis collection.)

With the Maple Marching Band pounding the school's fight song, Birmingham Seaholm charges into their 1983 playoff game with city rival Birmingham Brother Rice. (Observer and Eccentric.)

WE'VE GOT SPIRIT

Big games mean big events. Here Royal Oak Kimball's leading ladies lead the school's march through downtown Royal Oak before the Knights hosted Southfield High in Kimball's 1968 homecoming game. Homecoming is a game that usually involves the entire student body and is one of the reasons, unlike any other sport offered in scholastic athletics, football makes room for anyone who wants to be involved in almost any capacity. (Kimball Lancer, 1969.)

Playing the big room is a thrill for any student, but in the 1950s and 1960s, rare was the opportunity. Here Royal Oak Dondero's band presents a pregame show before a Detroit Lions' football game with the Chicago Bears at Tiger Stadium. Another metro Detroit rite of passage is being honored with an invitation to Detroit's annual Thanksgiving Day parade. Today many metro schools have played a regular season football game in Detroit's Ford Field or the now-vacant Pontiac Silverdome. (Dondero Oak, 1966.)

Junior Lynn Newman leads a rousing Kindle Kimball cheer

Burning the rival's spirit to the ground was a tradition of many high schools in the 1950s and 1960s. Here Dondero cheerleader Lynn Newman leads her classmates as Dondero High readies for the 1969 Kimball game with the annual bonfire. Perhaps it was that burning desire that helped the Oaks snatch a state title away from Kimball's clutches when they upset the undefeated Knights, who needed just one more win in the Oak Stump Game to earn the state's No. 1 ranking. Dondero ruined that dream with an 8-6 upset on November 7, 1969. (Dondero Oak, 1970).

Programs in the 1950s and 1960s were often sponsored by Coca-Cola, which would provide this inset art to a high school. The school's typesetting shop would produce the school's roster and lay it over this kind of art, usually found in the middle of the program. This is from a 1962 Catholic League playoff game between St. Thomas in Ann Arbor and the St. Mary's Fighting Irish of Royal Oak. St. Thomas became Ann Arbor Gabriel Richard; Royal Oak St. Mary's opened in 1953 and closed in the spring of 1985. (CHSL archive.)

WE'VE GOT SPIRIT

Playing their first season without the use of their famed stadium, the show goes on for the Dearborn Fordson High School marching band and flag corps in 1957. The high school football game is still filled with plenty of pomp and pageantry today and has added dance teams and parent booster clubs to the usual compliment of cheerleaders, bands, and student sections. (Fordson High School Library archive.)

Warren Lincoln's loyal followers get fired up for Warren Woods High in 1972 with the help of the Marching Abes, who ready themselves to take the field for the pregame victory march. High school marching bands play in busy shopping centers on weekends; pound out morning practices across wet grass; raise funds by selling oranges, candy, and pizza kits; and play pep assemblies and Friday morning spirit shows. They might not play a down but provide an essential harmony to high school football. (Lincoln Commander, 1973.)

Brother Rice's raucous student section celebrates a Warriors' win in the MHSAA Class A championship game of 1990 over Midland High in the Pontiac Silverdome. The high school athlete rarely, if ever, gets booed, and students root for fellow students, making most high school games a positively charged atmosphere no matter who wins or loses. Most schools take a pep band to road games to promote the school spirit whether the game is played at home or on the road. (Daily Tribune/Craig Gaffield.)

"The Star Spangled Banner" is a staple of the Friday night experience, as sung by Waterford Kettering's A Cappella Choir before the 1966 Naval Reserve Game, the trophy game for Kettering and Waterford Township High, which closed in 1983. Fight songs, alma maters, the national anthem, and spirit cheers were the norm in the 1950s and 1960s, and some of those traditions continue in different forms and expressions today. (Waterford Kettering Kismet, 1967.)

Kettering cheerleaders Mel Granfors (top) and Gayle Zollner cheer for the Captains in the 1971 Mott game at Kettering High. Starting in 1969, Mott joined Waterford Township as a staple of the Kettering schedule until Township High closed in the spring of 1983. Letter sweaters and saddle shoes have been replaced but cheerleaders, and school spirit remains in high school sports today. (Waterford Kettering Kismet, 1972.)

Just like big-time collegiate football, being named the school's drum major is a source of pride and honor in high school too. This drum major from the 1968 season is ready to lead his charges through the halftime performance. Marching bands march in precision and often have a specific step count into the stadium and onto the field, much more work than simply playing and walking at the same time. (Daily Tribune.)

It is Friday night under the lights, a scene played out in neighborhoods, communities, and counties all around the country. This is Royal Oak Kimball's homecoming versus Southfield's Blue Jays in 1969. Today this is Royal Oak High. When the original Royal Oak High School played its final football game in 1956, they faced Birmingham High before splitting into two schools. When the two schools merged back as the new Royal Oak High School in 2006, the first game was played here versus Birmingham Seaholm, formerly Birmingham High. Royal Oak's four different public high schools have played Birmingham's three public high schools 146 times since 1915 when the game was introduced between the two rivals. Royal Oak has earned 74 wins to Birmingham's 58 victories. Ten games ended in a tie. (Kimball Lancer, 1970.)

Across America, People are Discovering Something Wonderful. Their Heritage.

Arcadia Publishing is the leading local history publisher in the United States. With more than 3,000 titles in print and hundreds of new titles released every year, Arcadia has extensive specialized experience chronicling the history of communities and celebrating America's hidden stories, bringing to life the people, places, and events from the past. To discover the history of other communities across the nation, please visit:

www.arcadiapublishing.com

Customized search tools allow you to find regional history books about the town where you grew up, the cities where your friends and family live, the town where your parents met, or even that retirement spot you've been dreaming about.